Postcard History Series

Riverside

in Vintage Postcards

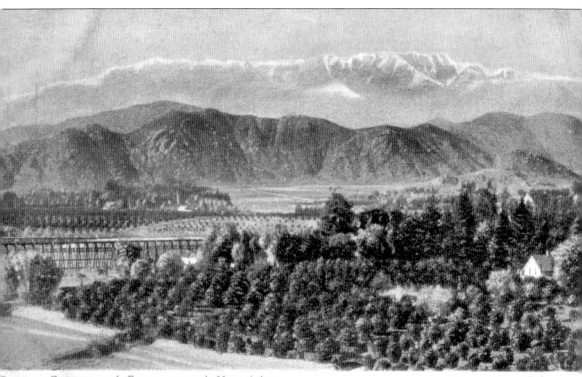

Orange Groves and Snow capped Mountains. Riverside, Cal.

PICTURE VIEW OF RIVERSIDE'S AMENITIES, 1905. This view sums up all that Riverside had to show the world at the turn of the last century. The snowcapped mountains in the distance, the burgeoning orange groves that were making the city wealthy, and the water system (note the elevated canals on the left) allowed Riversiders to grow citrus in a semi-desert environment. Cards like this one did much to show friends and loved ones in the colder, eastern climates just what was in store for them if they came west to Riverside.

Postcard History Series

Riverside
in Vintage Postcards

Steve Lech

ARCADIA

Copyright © 2005 by Steve Lech
ISBN 0-7385-2978-8

Published by Arcadia Publishing
Charleston SC, Chicago IL, Portsmouth NH, San Francisco CA

Printed in Great Britain

Library of Congress Catalog Card Number: 2005920112

For all general information contact Arcadia Publishing at:
Telephone 843-853-2070
Fax 843-853-0044
E-mail sales@arcadiapublishing.com
For customer service and orders:
Toll-Free 1-888-313-2665

Visit us on the internet at http://www.arcadiapublishing.com

Contents

Acknowledgments		6
Introduction		7
1.	Downtown Street Scenes and Businesses	9
2.	Public Buildings and Parks	23
3.	The Mission Inn	43
4.	Mt. Rubidoux and the Santa Ana River	69
5.	Magnolia and Victoria Avenues	81
6.	Other Views	105
7.	Close Neighbors	121
Bibliography		128

Acknowledgments

This book is dedicated to my wife, Tracy, our daughter Katarzyna, and all of my friends and cohorts who have encouraged me to continue researching local history.

I would like to acknowledge and thank Frasher's Fotos of Pomona for allowing me to publish some of their photos which appeared as postcards.

INTRODUCTION

At the dawn of the 20th century, Riverside was basking in the tremendous wealth brought about by the burgeoning navel orange industry, a large influx of wealthy tourists with money to invest, and a climate that drew snowbirds west.

By that time, Riverside had already seen remarkable progress. Founded in 1870 as a colony with social-Darwinist aims, Riverside soon gained international fame when it was discovered that the navel orange could be grown, packed, and shipped from here in great numbers. In 1883, Riversiders opted to form their own city government, and hoped to use their new independence to attract more sightseers during an era when tourists and investors were practically one and the same. Ten years later, Riverside rallied several neighboring towns to the cause of county division, and was able to create Riverside County with Riverside as the county seat. This was to be a great economic boon to Riverside, and help propel Riverside, in 1895, to be designated the city with the highest per-capita income in the country.

However, Riversiders were not content to rest on their laurels, and they continued to seek additional investors to the town. At the beginning of the 20th century, they had a new medium with which to attract people—the picture postcard. From roughly 1900 to 1940, when most of the views contained in this book date, literally hundreds of different postcards were printed by the thousands, all depicting various scenes that were admired by visitors and promoted by Riversiders. Some of the cards depicted street scenes, and are a wonderful tool to study the evolution of Main Street and others. Other cards showed businesses, elegant buildings, tropical plants that would grow in the climate, natural and man-made amenities that could be enjoyed here, and of course, Riverside's own Mission Inn. These postcards were sent to friends and loved ones all across the United States to display to those recipients the amenities that Riverside had to offer. Riversiders hoped that these views would attract new settlers and investors to Riverside in an era when residential development meant well-built and architecturally pleasing houses, and new commercial uses meant local businesses (not big-box chains) that operated locally and reinvested their earnings locally.

The views of Riverside contained in this book all come from my personal collection of nearly 2,500 postcards of Riverside County. They are divided into six categories: Main Street and downtown businesses, public buildings and parks, the Mission Inn (which by itself has been described as the most photographed building for picture postcards in California), Mt. Rubidoux

and the Santa Ana River, Magnolia and Victoria Avenues, and miscellaneous views. A seventh category shows views of some of Riverside's close neighbors, including West Riverside (today's Rubidoux area), Highgrove, and others. The reader should keep in mind that in order to preserve historic accuracy, historic street references have been used throughout the book. Therefore, today's Mission Inn Avenue is referred to as Seventh Street, and University Avenue is Eighth Street, as both of the streets were called during the period covered by the book.

I hope you enjoy this mini-tour through Riverside's past—a time when our city was known for its orange groves and stately buildings, and before today's mind-numbing sprawl had enveloped it.

—Steve Lech

One
Downtown Street Scenes and Businesses

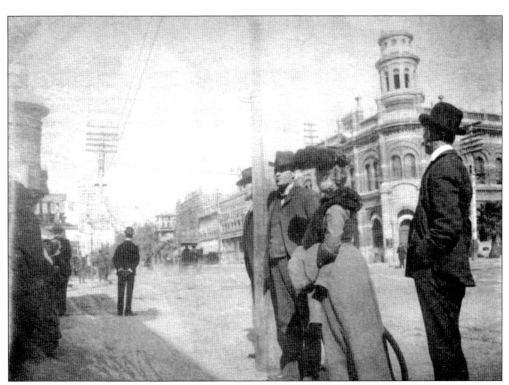

Gathering on Main Street, c. 1904. As was typical in most towns, Main Street was the primary business route, and Riverside was no exception. From its inception in 1870 until the 1960s, Main Street housed many of Riverside's primary businesses. The people in this view are congregating across the street from the Evans Building at Main and Eighth Streets. One can also make out the Mission Inn down the street.

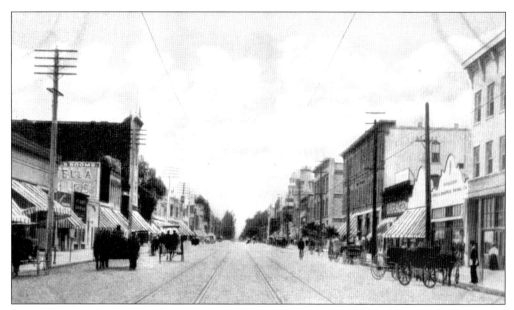

MAIN STREET LOOKING NORTH FROM TENTH STREET, C. 1903. The stately Evans and Castleman buildings are visible on the right at Eighth Street, and the building marked "Garage" is Theodore Crossley's Orange Valley Garage. A small population and a complete lack of cars made for a street with very little traffic.

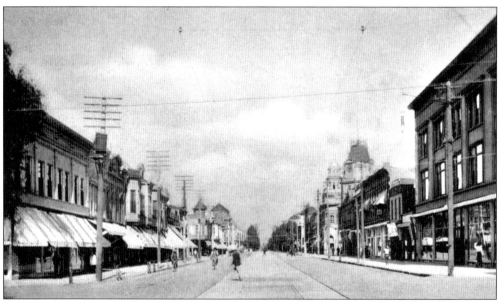

MAIN STREET LOOKING NORTH FROM NINTH STREET, C. 1905. The two buildings on the right with large cupolas are the Evans Building (farther) and Castleman Building, both at the corner of Eighth and Main. The Loring Building, at the northwest corner of Seventh and Main, is just visible. Note the dual trolley tracks in the center of the street.

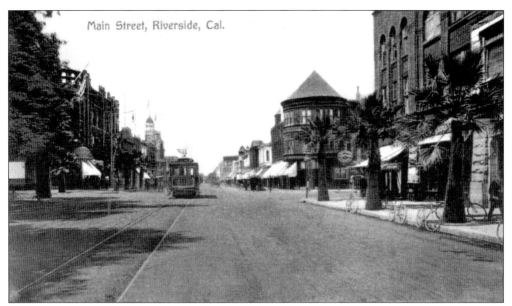

MAIN STREET LOOKING SOUTH FROM BETWEEN SIXTH AND SEVENTH STREETS, C. 1905. The building to the left of the trolley is the Rubidoux Building, while the one to the right with the turret feature is the Hayt Building. A portion of the Loring Building is seen immediately to the right, and, if the picture was a bit wider, one would see the Glenwood Mission Inn to the left.

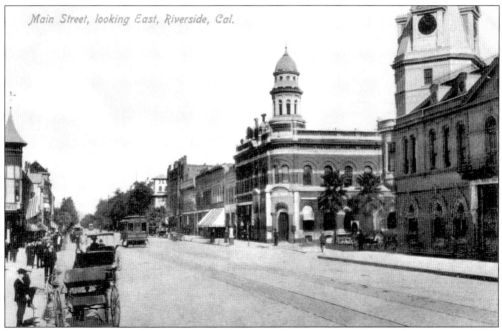

MAIN STREET LOOKING NORTH FROM BETWEEN EIGHTH AND NINTH STREETS, C. 1907. Visible on the right is the Castleman Building. Across Eighth Street is the Evans Building, and a block down is the southwest corner of the new Glenwood Mission Inn.

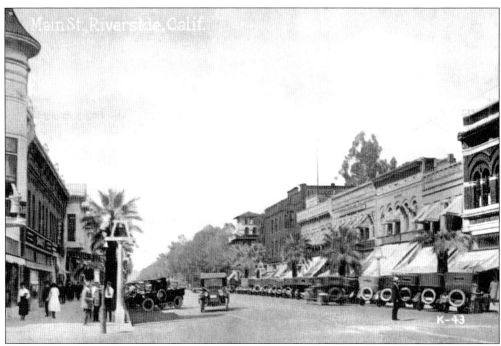

MAIN STREET LOOKING NORTH FROM EIGHTH STREET, C. 1925. Riverside's business center looks quite different and full of automobile traffic in this shot. A portion of the Mission Inn is visible in the center of the picture. Note the Raincross lamppost, which had been in use since 1908.

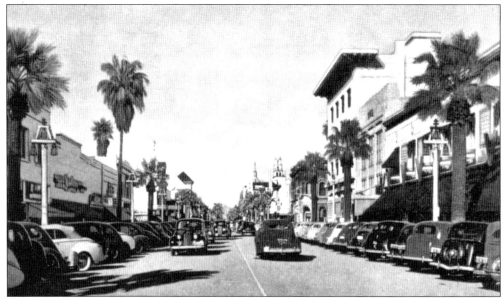

MAIN STREET LOOKING NORTH FROM BETWEEN EIGHTH AND NINTH STREETS, C. 1936. In this shot, the Mission Inn has been completed (1931), the Evans Building has lost its cupola, and the Castleman Building has been replaced by the First National Bank Building at the southeast corner of Eighth and Main Streets.

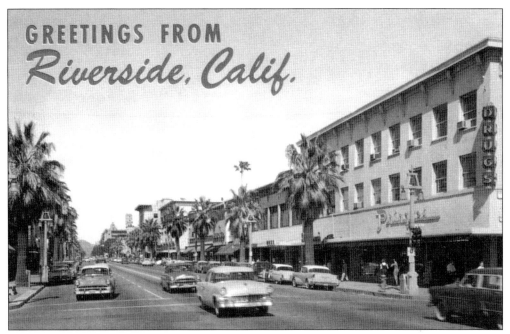

MAIN STREET LOOKING NORTH FROM TENTH STREET, C. 1956. Pringle's Drug Store on the right is in the Pennsylvania Building. Visible toward the center is the Mission Inn. Riverside is just beginning its conversion to a suburban lifestyle, and within a few years of this photo, many of the businesses seen above would be gone.

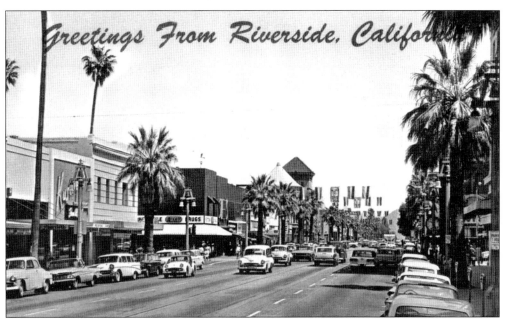

MAIN STREET LOOKING NORTH FROM NINTH STREET, C. 1960. The two towers just right of center belong to the Loring Building and the Hayt Building, both at the corner of Seventh and Main Streets. The Rexall Drug Store is in the old Odd Fellows Building at Eighth and Main Streets.

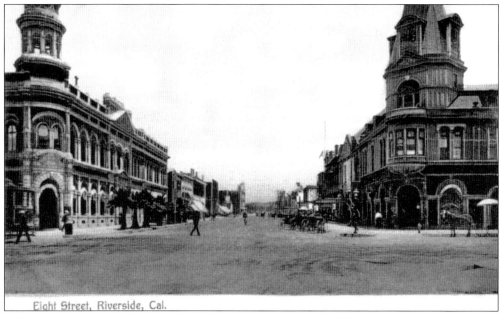

EIGHTH STREET LOOKING EAST FROM MAIN STREET, C. 1905. This view shows Eighth Street (the eastern entrance into Riverside) as it heads toward the Moreno Valley area.

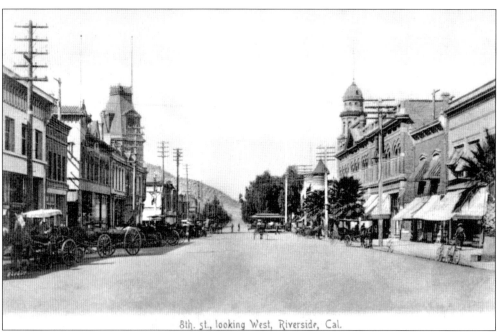

EIGHTH STREET LOOKING WEST FROM ORANGE STREET, C. 1905. Both Seventh and Eighth Streets became the major east/west entrances to the city—Seventh Street from the west, and Eighth from the east. If you had traveled into Riverside at this time from what is today Moreno Valley, this would have been the view that greeted you in Riverside. The Evans Building is at the right, and the Castleman Building on the left.

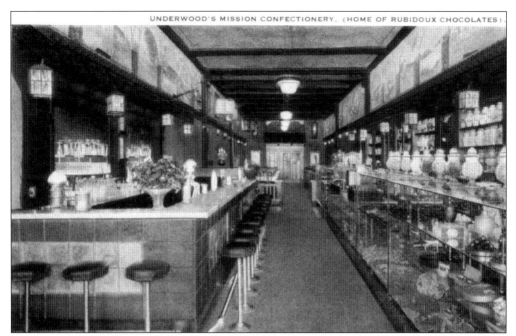

UNDERWOOD'S CONFECTIONARY, C. 1915. Underwood's Mission Confectionary, located on the east side of Main Street between Ninth and Tenth Streets, was a popular place for sodas, ice cream, etc. from 1910 to 1924. It was owned and operated by Charles Underwood. Beforehand, it had been the Heiser and Ryerson Confectionary, and after 1924, was renamed the Rubidoux Mission Confectionary when brothers Otto and Brooks W. Lowentrout bought the business.

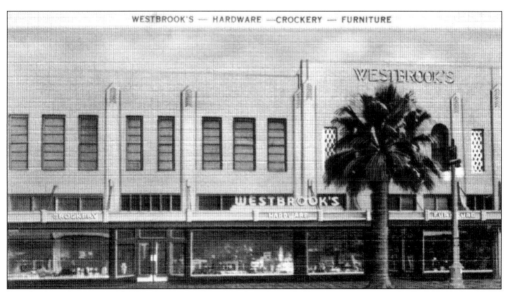

WESTBROOK'S HARDWARE STORE, C. 1936. Westbrook's Hardware began as the Franzen Hardware Company around 1900. It was located on the east side of Main Street between Seventh and Eighth Streets. In 1935, longtime manager John Westbrook took over the company and remodeled the building as shown above. Westbrook remained, selling housewares, furniture, and appliances. Westbrook's later became the Imperial Hardware Company.

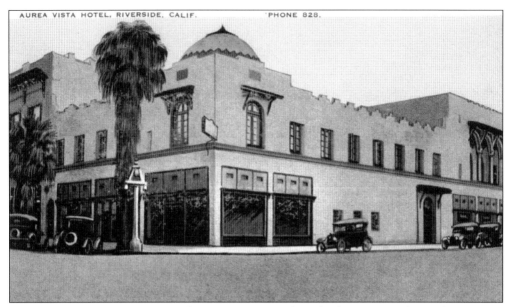

AUREA VISTA HOTEL, C. 1930. The Aurea Vista Hotel was built in 1927 at the southeast corner of Eighth and Lemon Streets by G. Stanley Wilson. It had 20 small rooms and a combination dining/ball room. The hotel catered to overnight guests (as opposed to the long-term guests of the Mission Inn), and occasionally housed overflow from the YMCA building directly across the street.

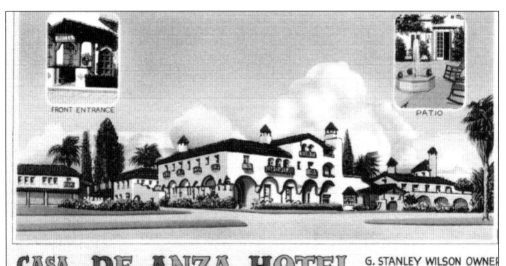

CASA DE ANZA HOTEL, EARLY 1930S. The Casa de Anza Hotel, on the west side of Market Street between Fourth and Fifth Streets, was originally a set of duplexes moved to the site in the early 1920s. Prominent local architect G. Stanley Wilson, labeled here as the hotel's owner, designed and built a hotel around them in 1929. Once Riversiders discovered that Anza had traveled through the Riverside area, several "de Anza" commemoratives, including Wilson's hotel, were constructed.

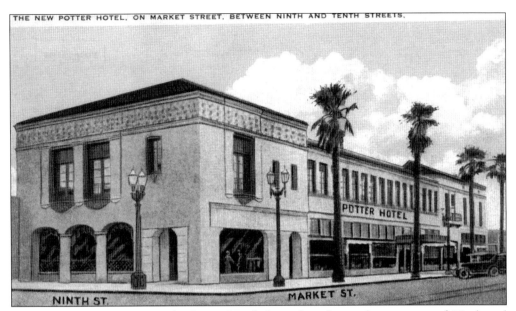

POTTER HOTEL, C. 1925. The Potter Hotel, located at the southeast corner of Ninth and Market Streets, was one of many smaller hotels to inhabit downtown Riverside. This one boasted that "it is more like a home than a hotel . . . every room [has] a bath, fine light, and ventilation." The building, slightly modified, still exists opposite White Park.

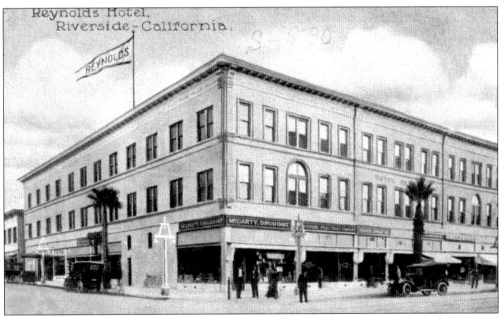

REYNOLD'S HOTEL, C. 1915. The building was located at the southeast corner of Ninth and Main Streets, and began as the Rowell Hotel in 1886. By 1902, George Reynolds had purchased the building and was hoping to renovate it into a deluxe hotel. However, many factors led to his not being able to accomplish all of his goals, not the least of which was the better financed and more energetic Frank Miller, who was just starting on the new hotel that would become the Mission Inn.

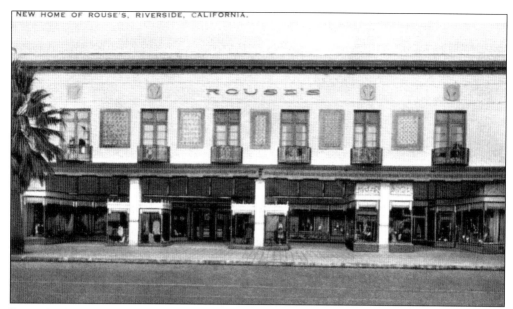

ROUSE'S DEPARTMENT STORE, C. 1928. Rouse's was one of the most popular shopping destinations for Riversiders during the first half of the 20th century. This view shows Rouse's, located on the east side of Main Street between Eighth and Ninth Streets, shortly after the building was remodeled in 1924. At that time, G. Stanley Wilson modified the look to a Spanish theme.

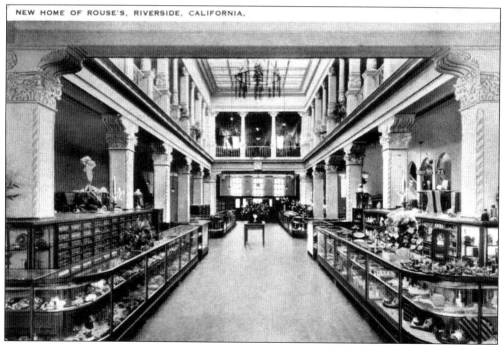

INTERIOR VIEW OF ROUSE'S, C. 1928. Rouse's specialized in clothing, accessories, and many other things. Founded c. 1890 by Gaylor Rouse of New York, Rouse's lasted into the 1950s, but fell victim to the decline of downtown.

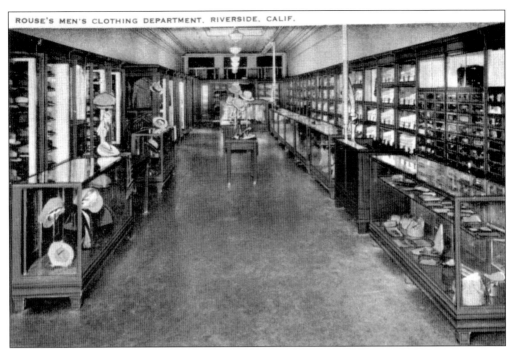

ROUSE'S MEN'S STORE, C. 1910. This was to the right (south) of the main Rouse's Department Store, and has recently housed a series of restaurants.

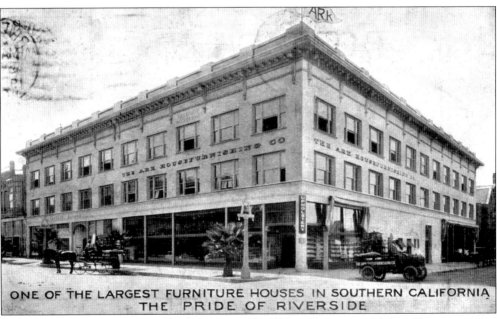

THE ARK STORE, C. 1910. The Ark House Furnishing Company of Riverside was a major player in Riverside's retail market from 1898 to about 1939. The Ark was established by Henry Miller, who had come from the Midwest in about 1890. By 1898, he had established the store, which had several locations throughout its life. This view shows its location at the southeast corner of Eighth and Lemon Streets.

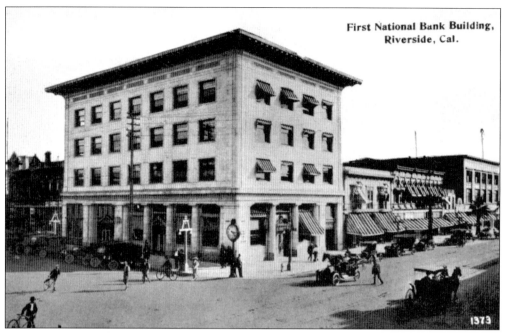

FIRST NATIONAL BANK BUILDING, C. 1912. Established in 1885, Riverside's First National Bank had grown such by 1911 that it warranted a new building, and the one shown above was built in that year. The view is looking southeast from the corner of Eighth and Main Streets. First National Bank was later taken over by Citizens Bank in 1915.

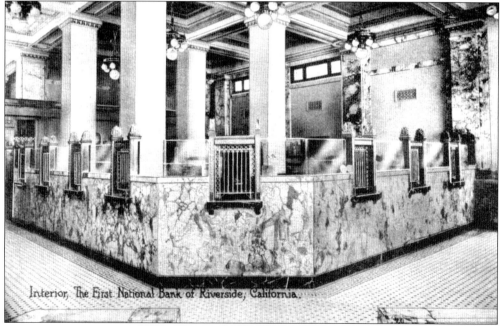

INTERIOR, FIRST NATIONAL BANK BUILDING. This view was meant to denote the strength and security afforded a customer of Riverside's First National Bank. Although this interior scene no longer exists, the building still stands, having seen many different uses in its years.

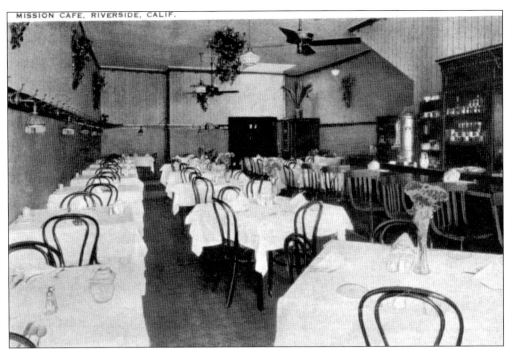

MISSION CAFÉ, C. 1915. The Mission Café was located opposite the Mission Inn on Seventh Street, and featured "seasonable goods, well cooked, nicely served, and at moderate prices." This would have been one of many inexpensive alternatives to the Mission Inn.

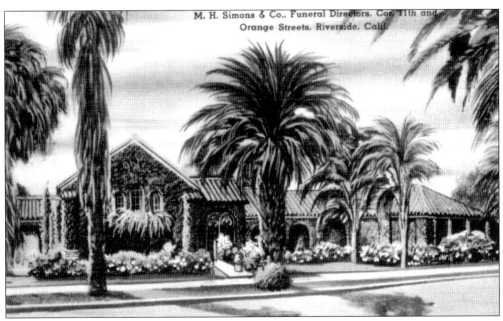

M.H. SIMONS UNDERTAKING CHAPEL, LATE 1920S. This building, at the southwest corner of Eleventh and Orange Streets, was built specifically for Melvin Simons' undertaking business in 1925. Designed and built by G. Stanley Wilson, this city landmark has since housed the offices of the Riverside County Coroner.

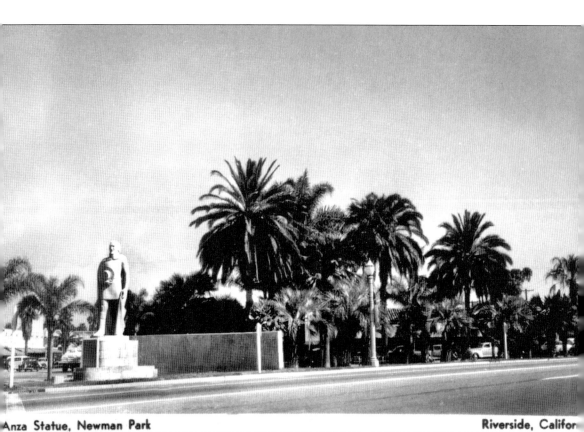

NEWMAN PARK AND DE ANZA STATUE, C. 1940. The triangular park was created when Market Street and Magnolia Avenue were connected at Fourteenth Street in 1916. The de Anza statue is a product of the WPA. Sculptor Sherry Peticolas received money from the Riverside Art Alliance and WPA to complete the statue, which was dedicated in May 1940. Anza faces southwest, overlooking the route he traveled in 1774 through what would become Riverside.

Two
Public Buildings and Parks

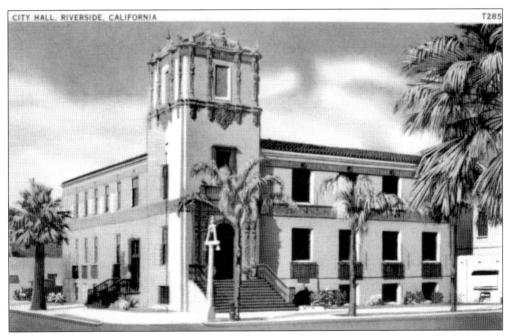

Old City Hall, c. 1930. This building, built in 1924 at the southwest corner of Seventh and Orange Streets, was Riverside's first City Hall. Before that, city offices were in rented quarters in various other buildings. Built in Spanish Renaissance style, it complemented the Mission Inn across the street. This City Hall building served Riverside until 1973 when the present City Hall was built on Main Street between Ninth and Tenth.

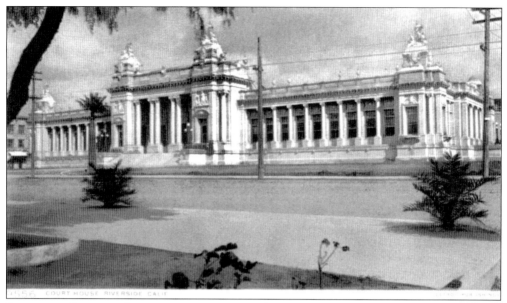

RIVERSIDE COUNTY COURTHOUSE, C. 1910. The Riverside County Courthouse, located on the east side of Main Street between Tenth and Eleventh Streets, was built in 1903–1904 and opened for business in June 1904. At that time, it housed all Riverside County government offices, including the one courtroom that existed for the entire county. Designed by Franklin Pierce Burnham, it was built in the Beaux Arts style of architecture and patterned after the Grand and Petite Palais constructed for the 1900 Paris Exposition.

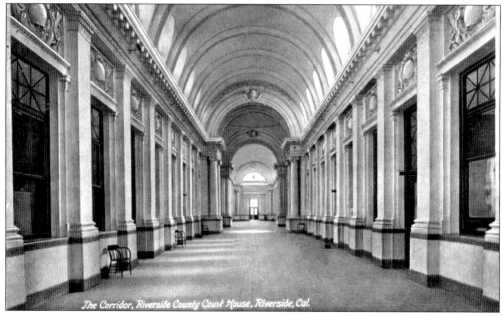

HALLWAY OF THE RIVERSIDE COUNTY COURTHOUSE, C. 1905. Resembling the Roman baths, this hallway is nearly 200 feet long. In the center and over the rotunda, a 45-foot-high dome leads into Department 1—the only courtroom in all of Riverside County for nearly 20 years.

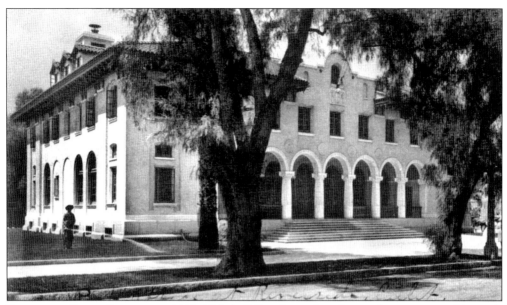

RIVERSIDE POST OFFICE, C. 1912. This building, located at the southeast corner of Seventh and Orange Streets, was Riverside's first dedicated post office, and was built in 1912 by architect James Taylor. He combined two different architectural types: the standard neoclassical and Mission Revival, which was still fairly new. Since its construction, the building has served as the post office, the headquarters for the 4th Air Force (during World War II), the police station (1946), and the municipal museum (since 1966).

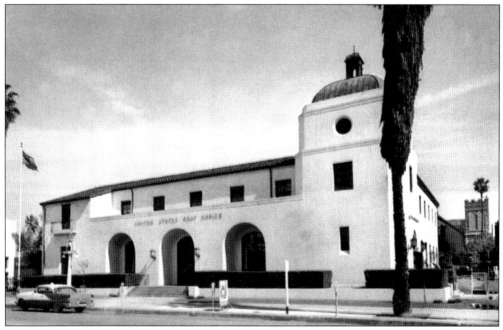

RIVERSIDE DOWNTOWN POST OFFICE, C. 1955. This building, constructed in 1939 using Mission style architecture, replaced the 1912 post office a few blocks away. The 1939 post office building, still in use today, is located at the northeast corner of Ninth and Orange Streets.

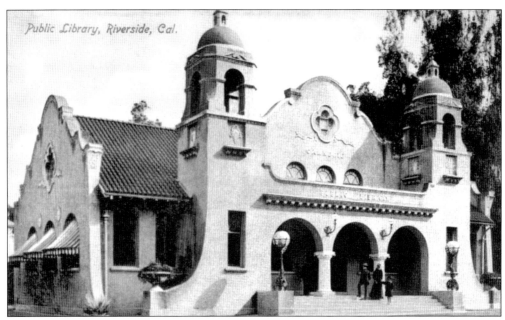

RIVERSIDE CARNEGIE LIBRARY, C. 1910. This building was Riverside's first dedicated library building, and opened on July 31, 1903, at the northeast corner of Seventh and Orange Streets. The architectural firm of Burnham and Bleisner designed this building in the Mission style at the behest of the library board and city council. The Carnegie Library was demolished in 1964 just after the present library building was opened.

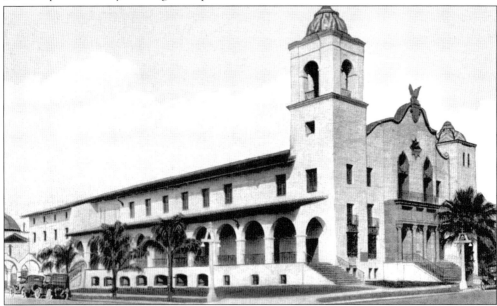

MUNICIPAL AUDITORIUM AND SOLDIERS' MEMORIAL BUILDING, C. 1925. This greatly needed civic improvement was dedicated in March 1929 to Riverside's veterans of World War I. Located at the northeast corner of Seventh and Lemon Streets, the building has elements of Mission and Spanish style architecture. It was designed by Arthur Benton and constructed by G. Stanley Wilson on land donated by Frank Miller.

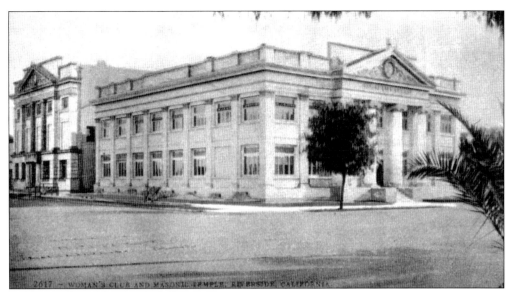

RIVERSIDE WOMEN'S CLUB, C. 1910. This Classical Revival building was constructed in 1908 for the Riverside Women's Club at the southeast corner of Eleventh and Main Streets. This building, though, soon proved to be too large. This led to the sale of the building to the Riverside Elks Club in 1915. The Women's Club then moved to their current site at the southeast corner of Tenth Street and Brockton Avenue.

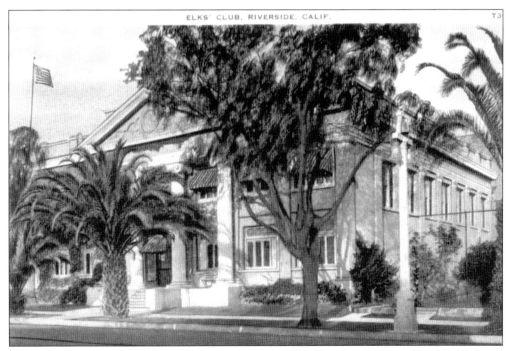

RIVERSIDE ELKS CLUB, C. 1920. Organized in 1901, the Riverside chapter of the BPOE found itself in need of a building and purchased the Riverside Women's Club building in 1915. This building was used until 1956, when the Elks moved to their current location on Brockton Avenue between Jurupa and Merrill. The building in the picture was torn down in 1959.

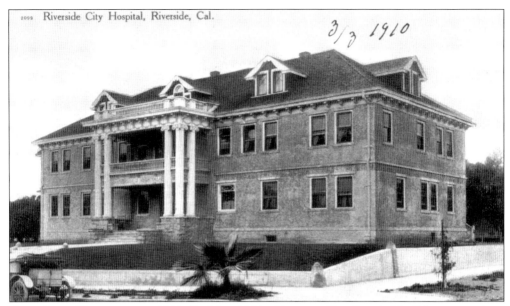

OLD CITY HOSPITAL, C. 1910. In May 1904, this new City Hospital building opened on Walnut Avenue (present-day Brockton Avenue) between Twelfth and Thirteenth Streets. A coalition of Riverside physicians, led by Dr. C. Van Zwalenburg, joined together, sold stock, and raised money for this building, Riverside's first true hospital building. It was a thoroughly modern facility, having a sterilizing room, operating room, and quarantine area.

AERIAL VIEW OF RIVERSIDE COMMUNITY HOSPITAL, LATE 1920S. By early 1921, Riverside physicians were again campaigning for a new site for a larger hospital. The new hospital site selected was the old Newman Ranch, located at the southwest corner of Fourteenth Street and "New" Magnolia Avenue. Here, in March 1925, the new Riverside Community Hospital opened as an 85-bed, state-of-the-art facility.

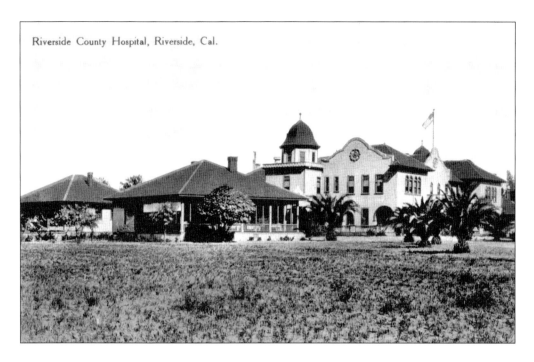

RIVERSIDE COUNTY HOSPITAL, 1905–1910. Located on Magnolia Avenue just south of Arlington, the building was built by Riverside contractor A. W. Boggs in 1900. This building was actually the sixth facility used as a county hospital. It was replaced in the mid-1930s by the much larger Riverside General Hospital, which itself was recently replaced by the Riverside County Regional Medical Center in Moreno Valley.

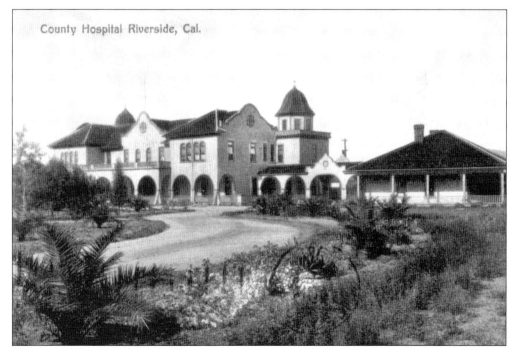

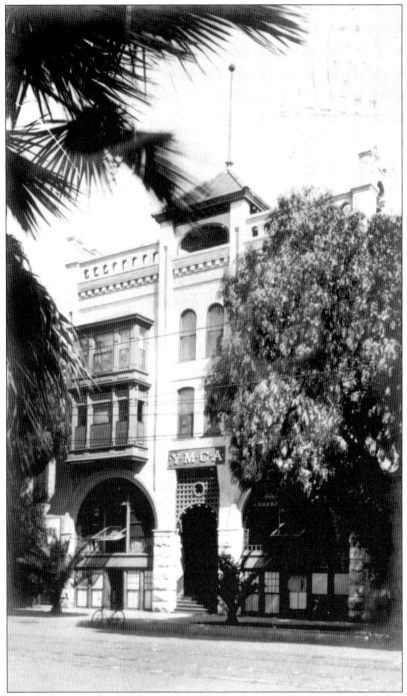

FIRST YMCA BUILDING, C. 1906. Located approximately where the Rotunda of the Mission Inn is today, this building was built in 1888. In 1893, it barely missed out becoming one of Riverside County's first county buildings. The YMCA occupied the site until 1909, when they moved to the northeast corner of Eighth and Lemon Streets. The above building was removed in 1929 to make way for the Mission Inn Rotunda.

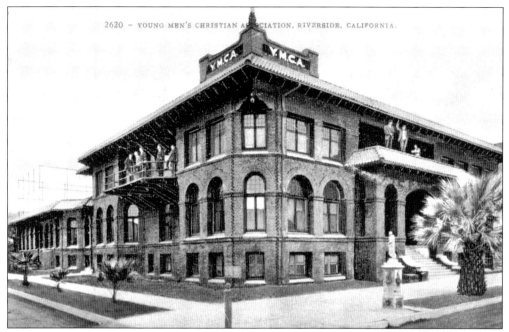

YMCA BUILDING, C. 1910. This is the 1909 YMCA building located at the northeast corner of Eighth and Lemon Streets. This new YMCA building was influenced by the Mission style of architecture, which is not surprising given that one of the major supporters of the YMCA was Frank Miller. This building was in use from 1909 to 1968. Note the fountain placed by the Women's Christian Temperance Union in front—this fountain is now in front of the Municipal Museum.

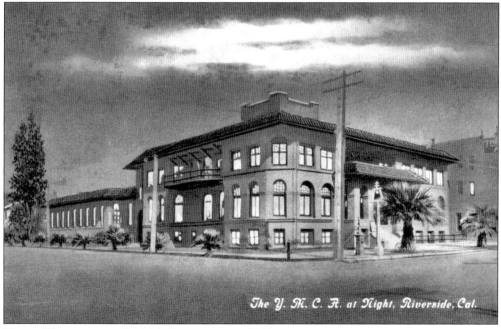

NIGHT VIEW OF THE YMCA BUILDING, C. 1910.

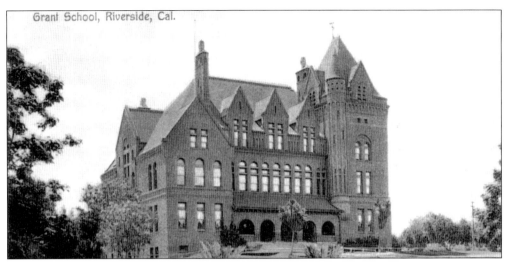

GRANT SCHOOL, C. 1908. This view is from along Brockton Avenue looking east, with Fourteenth Street to the right. Built in the gothic style in 1889, the bottom two floors were used originally for elementary classes, with the top floor occupied by the high school. This building was deemed unsafe following the 1933 Long Beach earthquake, and was torn down to make way for the present Mission-style building that is today's Grant School.

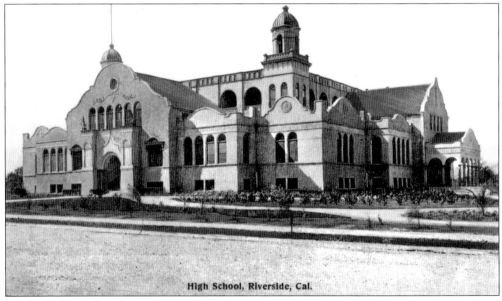

RIVERSIDE HIGH SCHOOL, C. 1905. This building was constructed specifically as a high school on the block bounded by Ninth, Tenth, Lemon, and Lime Streets, with the view looking southeast from the corner of Ninth and Lime. Built in the Mission Revival style to complement many other downtown buildings, it housed an ever-growing number of high school students. From about 1908 to 1912, the school day had to be divided, with boys attending in the mornings and girls in the afternoons. In 1912, the boys were moved to a new location, and this building was used as the Riverside Girls High School. In 1924, the girls were sent to the new location, and Poly High, as it was known by then, was made coeducational. The building pictured above became administrative offices and was torn down some years later.

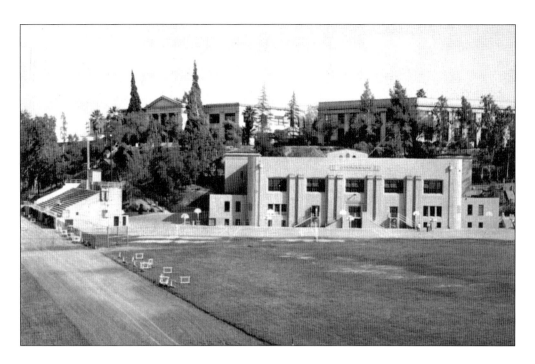

TWO VIEWS OF "OLD POLY." These buildings were opened in 1912, originally as the boys' high school, but later as a combined coed Poly High. Its location was overlooking the Tequesquite Arroyo just east of Magnolia Avenue. The top photo shows the classical-style buildings in about 1955, while the bottom aerial view was taken approximately eight years later. These buildings were removed in 1967 for additional classrooms at RCC and the Martin Luther King Library. The present Poly High School, at Central and Victoria Avenues, opened in 1966.

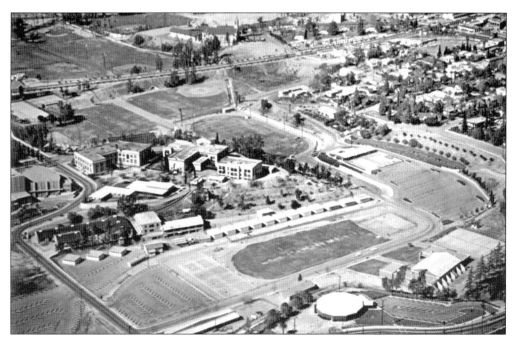

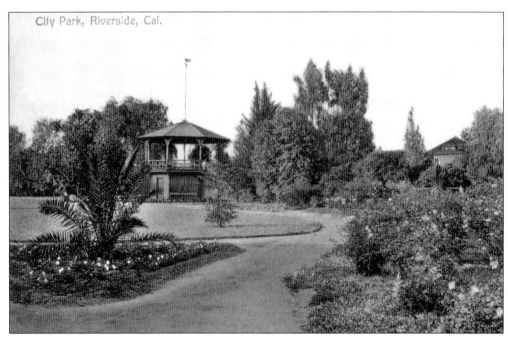

CITY PARK, C. 1905. City Park began in 1883, but was more of a duck-hunting area. Soon, local physician Clark Whittier convinced the city to allow him to grade and fill the low spots in exchange for half the land.

CITY PARK, C. 1909. Eventually City Park sported a bandstand, several paths, lush vegetation, and the old Lower Canal, which went through the park and became one of the many sites to see. In 1909, City Park was named for Albert Sidney White, longtime Riverside political dignitary.

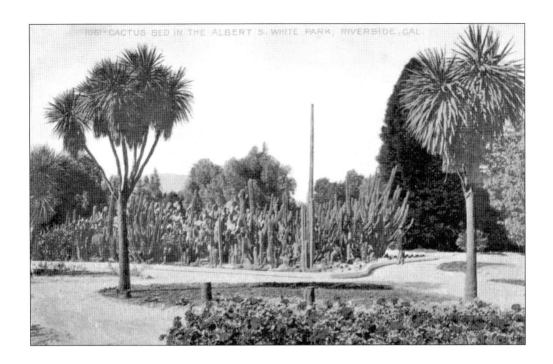

CITY PARK CACTUS GARDEN, EARLY 1900S. One of the main attractions of City/White Park was the large cactus garden, which displayed many varieties of cactus to curious visitors from the Midwest and East, many of whom had never seen a desert plant before.

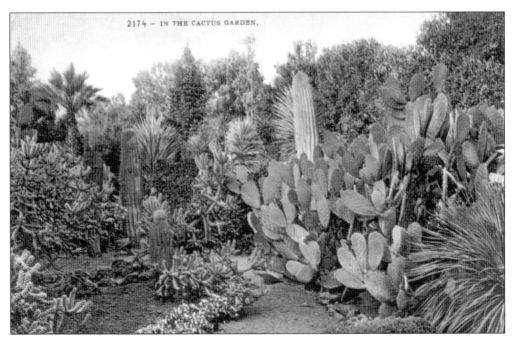

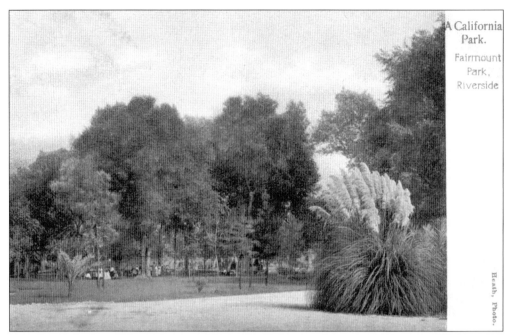

FAIRMOUNT PARK GATHERING, C. 1905. Officially opened on April 9, 1898, Fairmount Park began with 35 acres. Over the next several years, it grew to approximately 180 acres through land donations, much of them from the Evans family. This scene shows one of many gatherings held in the park during those years.

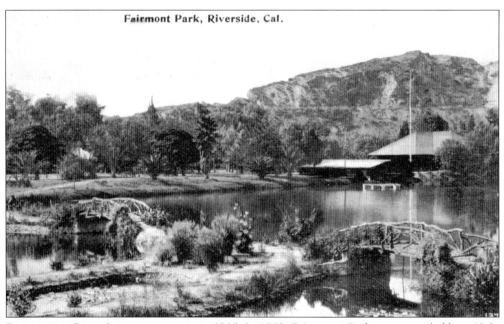

FAIRMOUNT LAKE IMPROVEMENTS, C. 1905. In 1903, Fairmount Park was expanded by a 12.5-acre donation of land, and Spring Brook, which runs through the park, was dammed, creating Fairmount Lake. As seen here, bridges were erected across it, and a walkway was placed surrounding the lake.

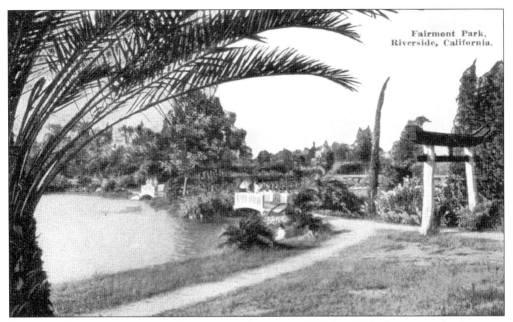

FURTHER IMPROVEMENTS TO FAIRMOUNT PARK, C. 1920. In 1910, downtown businessman George Reynolds returned from a trip to the Orient and gave money for improvements to the park. They included the Japanese-style bridges and archways shown here, as well as the lily pond on the east side of Fairmount Lake.

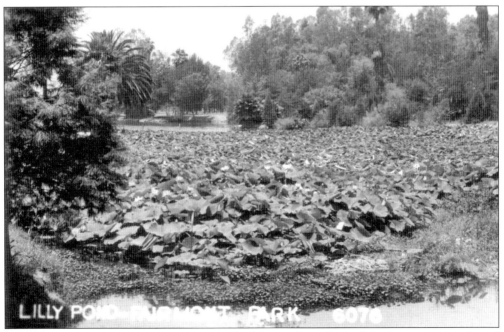

FAIRMOUNT PARK LILY POND, 1920S. This lily pond was located in the eastern portion of Fairmount Lake and was one of many attractions in Fairmount Park.

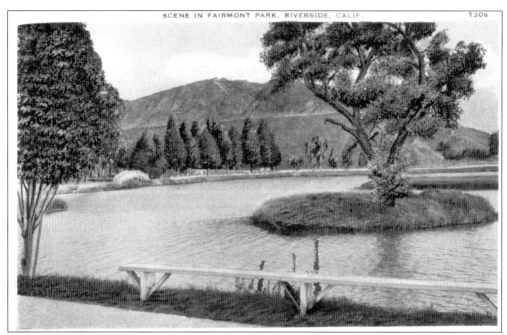

LAKE EVANS, 1920s. This postcard shows the larger Lake Evans, added in 1924 and named for the Evans family. Today, Lake Evans is the larger of the lakes in Fairmount Park.

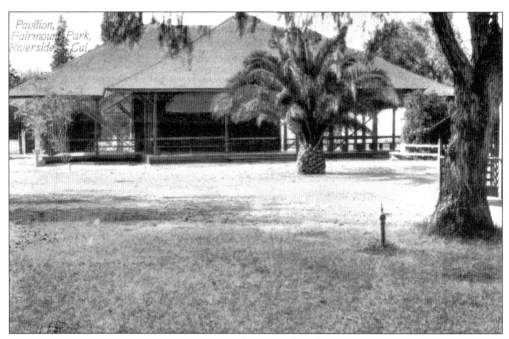

FAIRMOUNT PARK PAVILION, 1900s. Most larger parks of the day had pavilions, which were used for a multitude of purposes. Fairmount Park was no exception, and this pavilion housed several different events in its day.

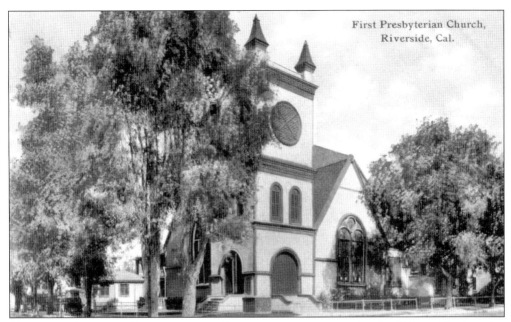

ORIGINAL CALVARY PRESBYTERIAN CHURCH BUILDING, C. 1910. Calvary Presbyterian Church was organized in 1887, and by 1890 it had grown enough to warrant the construction of this building at the northeast corner of Ninth and Lime Streets. This was the primary location until 1936, when the church moved to its present location on Magnolia Avenue.

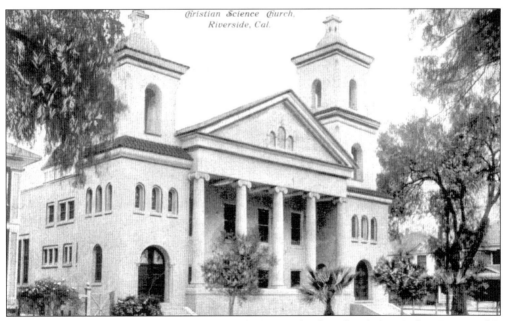

CHRISTIAN SCIENCE CHURCH, C. 1910. Built in 1901 by famed architect Arthur Benton, this building is a mix of Spanish, Mission, and Classical Greco-Roman architecture. This church is reputed to be the one that introduced Christian Science teachings to Southern California. The building is located at the southeast corner of Sixth and Lemon Streets, with the view in this postcard on Sixth Street.

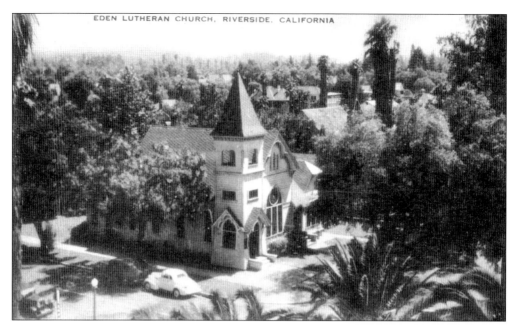

EDEN LUTHERAN CHURCH, C. 1945. This church, organized on September 28, 1888, as the Scandinavian Evangelical Lutheran Eden Church, built this structure on the southeast corner of Eleventh and Orange Streets in 1891. It was in use until the present structure on Brockton Avenue was constructed.

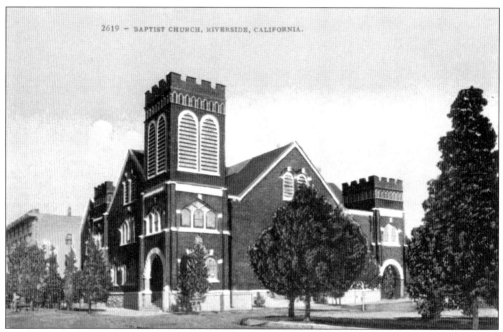

FIRST BAPTIST CHURCH BUILDING, C. 1910. Riverside's First Baptist Church was organized in February 1874. For several years the members had a church at Eighth and Lemon, but it was sold for retail purposes. In 1909, they built and moved into the building depicted above at the northeast corner of Ninth and Lemon Streets.

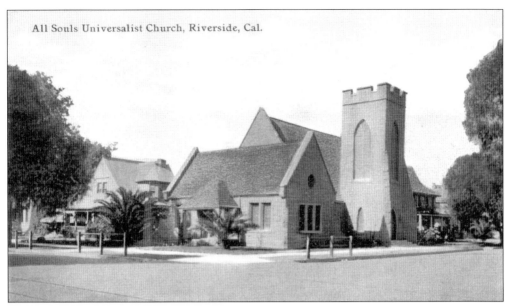

ALL SOULS' UNIVERSALIST UNITARIAN CHURCH, C. 1910. This church was organized by Rev. Dr. George Deere in July 1881. In 1891, the group purchased land at the northwest corner of Seventh and Lemon Streets and built this Norman Gothic Revival structure under the guidance of architect A.C. Willard. This building remains today as one of Riverside's landmarks.

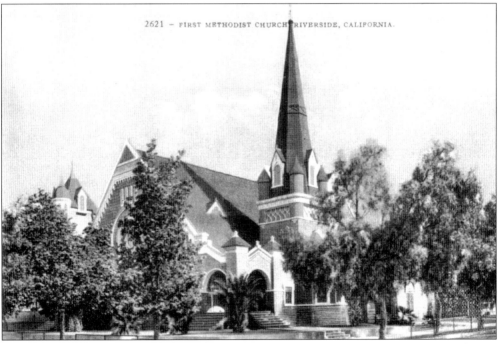

FIRST METHODIST CHURCH BUILDING, C. 1912. This building started in 1875 as a 24- by 36-foot brick chapel located at the northeast corner of Sixth and Orange Streets. Over the years it was remodeled and enlarged several times. The Methodist Church was Riverside's second, having been organized in 1874 by Rev. M.M. Bovard.

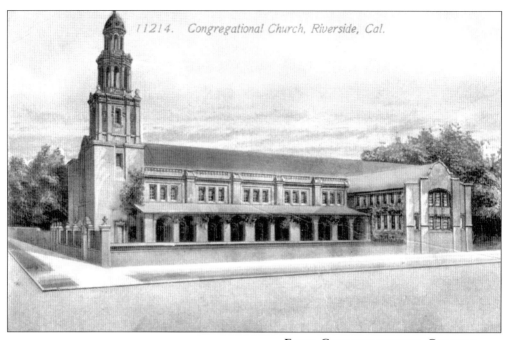

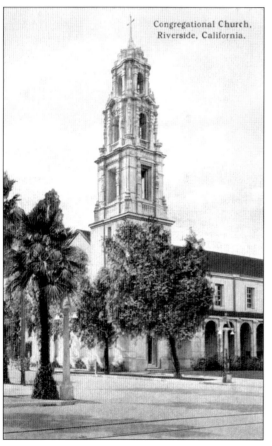

FIRST CONGREGATIONAL CHURCH, C. 1915. This building, at the southwest corner of Seventh and Lemon Streets, was constructed in 1912 and replaced a smaller, wooden church building dating to 1887. Founded in 1872, the First Congregational Church has been dubbed "Riverside's first church."

BELL TOWER, FIRST CONGREGATIONAL CHURCH, C. 1920.

Three
THE MISSION INN

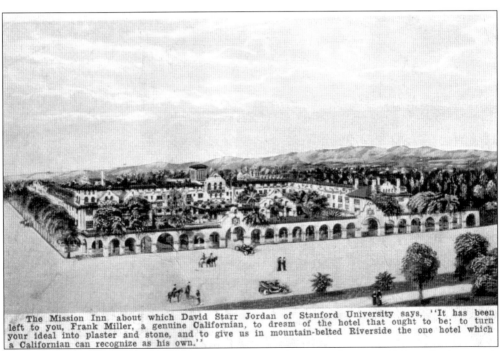

The Mission Inn about which David Starr Jordan of Stanford University says, "It has been left to you, Frank Miller, a genuine Californian, to dream of the hotel that ought to be; to turn your ideal into plaster and stone, and to give us in mountain-belted Riverside the one hotel which a Californian can recognize as his own."

OVERALL VIEW OF THE MISSION INN, C. 1912. The quote from David Starr Jordan says it all—Frank Miller's hotel was one that "a Californian can recognize as his own." It was patterned after many of the Old Spanish missions, which still leads to confusion today. When the Mission Inn opened in 1903, it became an instant success. Miller and others had lobbied long and hard for a grand hotel in Riverside, and the Mission Inn was their crowning jewel.

ENTRANCE TO GLENWOOD TAVERN, RIVERSIDE.

GLENWOOD TAVERN, C. 1900. The Glenwood Tavern (also known as the Glenwood Hotel) was the precursor to the Mission Inn. It began on the present-day location of the Mission Inn in 1874 as a small, 12-room adobe for the family of Christopher Columbus Miller. Within a few years, additions were constructed and by the time of this view, the Glenwood Tavern had become a noteworthy, if not modest, hotel. This angle is looking north from Seventh Street toward the main entrance.

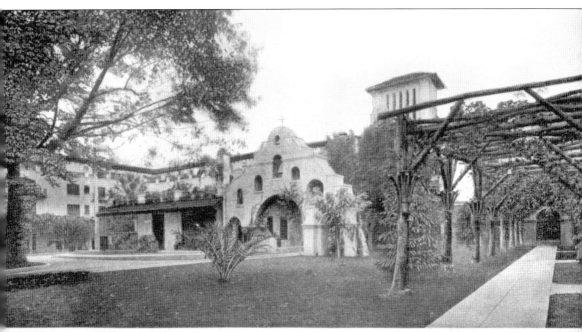

he Court and Pergola, Glenwood Hotel, Riverside, Cal.

MISSION INN COURTYARD, CAMPANILE, AND PERGOLA, C. 1905. Many postcards showed various scenes of the Mission Inn courtyard. In this view, one can see the pergola (vine-covered structure on the right) that was constructed as a shaded walkway around the courtyard. In addition to the pergola is the Campanile, or Mission-style bell tower that heralded guests to the main entrance of the hotel. Connected to the Campanile is the "Old Adobe" (the old Miller family home), which continued to serve guests in a variety of capacities.

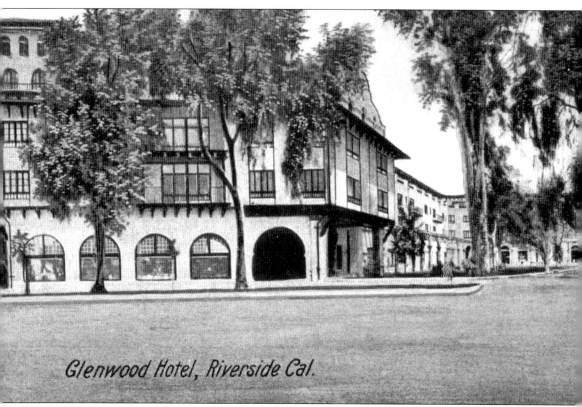

Glenwood Hotel, Riverside Cal.

PANORAMA OF THE NEW GLENWOOD MISSION INN, C. 1905. This folded, two-pane postcard shows the front of the new Glenwood Mission Inn on Seventh Street between Main and Orange Streets. This portion of the hotel is known as the Mission Wing, and encompassed roughly half the block when it was built in 1902–1903. An astute observer of the Mission Inn may note that the arches are missing—those were not constructed until 1908. However, the inner courtyard was still inviting and played host to many wealthy clients. Because the Mission Inn catered to wealthy guests coming to Riverside to escape the harsh eastern winters, there had to be an area where they could sit outside and relax in comfort. A poem written by Mission Inn architect Arthur Benton says of the courtyard:

A low-walled house with wings stretched wide/About a court whose open side/Is toward the southward and the sun./Around this spacious court doth run/A vine clad arbor good to see./Built from the eucalyptus tree/Whose sturdy trunks with palm leaves crowned/Still wrap their rugged bark around/Beneath the vines in stately row/Great buttressed Roman arches show/Above, ten score wide casements bright/The sun's free entering invite./Close to the walls rough stuccoed face/The ivy clings in fond embrace. /And Spanish balconies are there/Fit for the fairest of the fair.

Undoubtedly, many Mission Inn postcards were written in this courtyard and sent to loved ones back home.

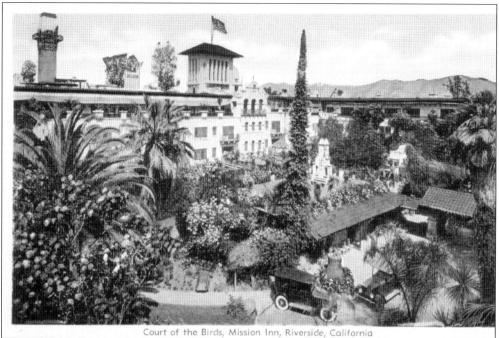

Court of the Birds, Mission Inn, Riverside, California

MISSION INN COURTYARD, LATE 1920S. Much has changed in the courtyard since the previous earlier views. The landscaping has grown to be a veritable garden with many different species of plants on display. An additional structure for reception has been added to the Old Adobe home, as have obvious auto paths throughout the courtyard. The skyline has changed too, with the addition of other buildings in the back.

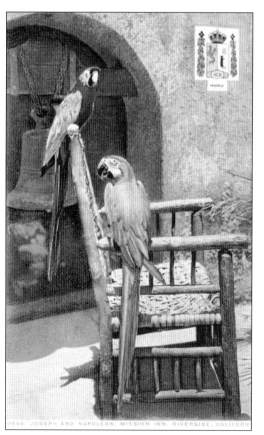

MISSION INN MACAWS, 1920S. The oft-used name of the courtyard is the Court of the Birds, named for these two macaws, Joseph (on the left, named for his coat of many colors), and Napoleon (named because his blue and yellow colors resembled Emperor Napoleon). These two were very popular attractions at the inn for many years.

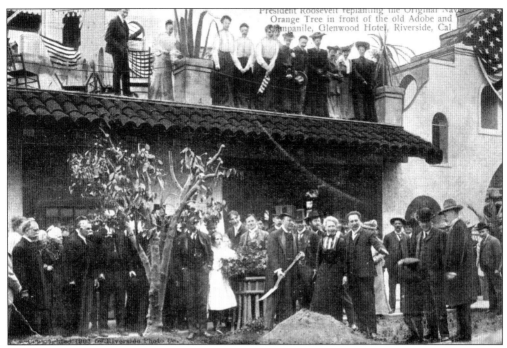

PRESIDENT THEODORE ROOSEVELT TRANSPLANTING PARENT NAVEL ORANGE TREE, MAY 8, 1903. "An Orange tree fenced with care/'Twas Roosevelt who set it there/Mother of half the trees that fill/The countless groves on plain and hill." During his overnight visit to Riverside, President Roosevelt toured hundreds of acres of orange groves and stayed at the new Glenwood Mission Inn. In one of his greatest publicity stunts, Frank Miller had President Roosevelt transplant the orange tree, which was one of two parent navel orange trees owned by Luther and Eliza Tibbetts, into the Mission Inn courtyard. The location of this tree was right in front of the Old Adobe.

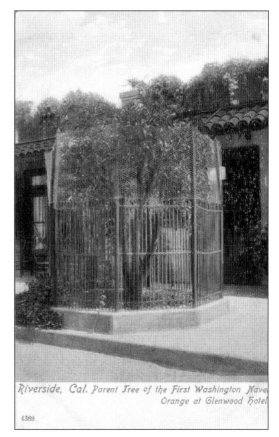

PARENT NAVEL ORANGE TREE, C. 1905. This tree was a much-vaunted attraction for the Mission Inn in the early years, but unfortunately it lasted only about 20 years. Upon its death in 1922, rumors swirled that Frank Miller had it chopped up and sold the pieces.

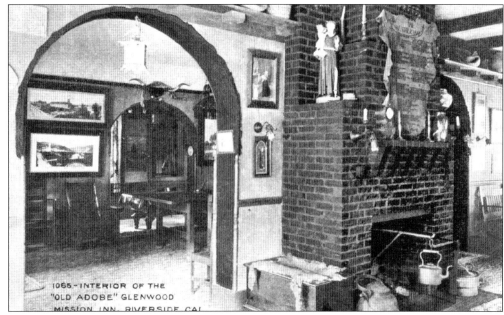

INTERIOR VIEW OF THE "OLD ADOBE," C. 1906. The "Old Adobe" was actually the original Miller family home, built in 1874. When the new Glenwood Mission Inn was constructed, the old home was made into a tearoom and casino, as shown in this view. This postcard describes the building as "one of the pioneer buildings of this fertile valley. . . . The old clinker fireplace, with its cheerful hearth and the numerous Indian baskets scattered about, are especially attractive."

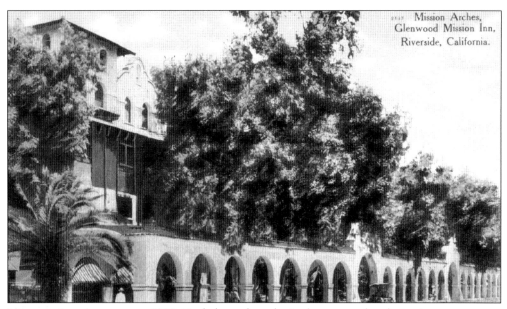

MISSION INN ARCHES, C. 1912. To help enclose the inn's courtyard and give it an even more "mission" feel, Frank Miller added these arches in 1908. It is variously stated that they are patterned after those at the San Juan Capistrano Mission, the San Fernando Mission, or several others. In truth, many missions had arches such as these. The two larger protrusions from the top of the arches signified the entrance and exit to the courtyard.

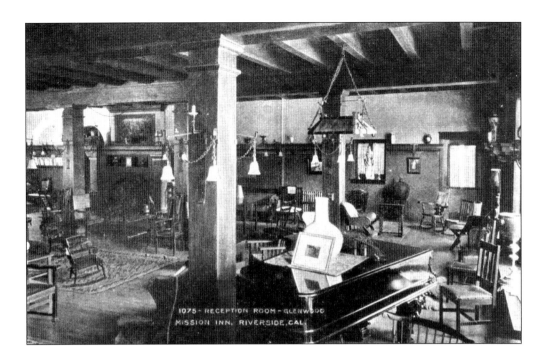

MISSION INN LOBBY, C. 1905. This portion of the lobby, closest to Orange Street, was used extensively for gatherings and entertaining (including afternoon tea) during the earliest years of the new Glenwood Mission Inn. Note the eclectic mix of furnishings and other items. This would be a hallmark of the Mission Inn for many years.

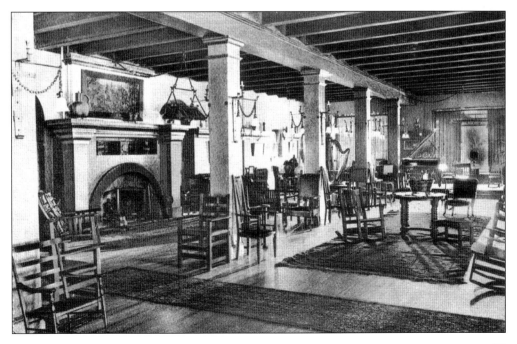

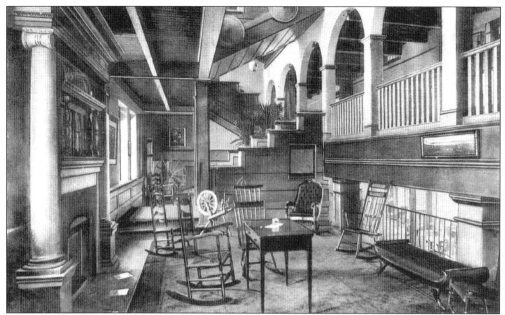

COLONIAL LANDING, C. 1910. When Albert Sidney White, an early Riverside political dignitary and longtime friend of Frank Miller, died in 1909, he willed his collection of colonial furniture to Frank Miller. Miller then placed the furniture on this landing directly above the front desk. It no longer exists, but the fireplace, seen to the left of the photo, can still be seen in the lobby of the Mission Inn.

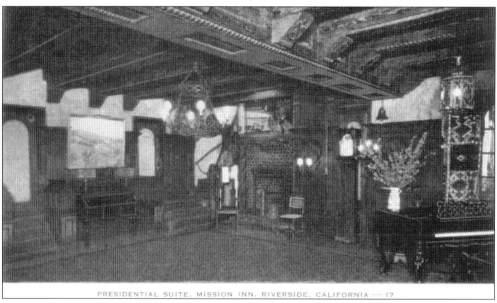

PRESIDENTIAL SUITE, C. 1910. When the Glenwood Mission Inn opened in January 1903 this room was the largest suite available, and was therefore given to President Theodore Roosevelt upon his visit to Riverside on May 7–8, 1903. At that time, the room was dedicated as the Presidential Suite. William Howard Taft would use it in 1909, and in June 1940, future President Richard Nixon and his wife Pat were married in the room.

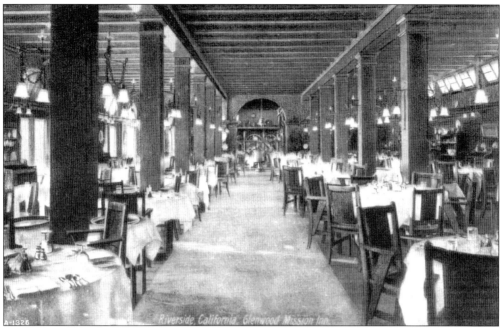

CALIFORNIA DINING ROOM, C. 1910. This room was known as the California Room, and was the main dining room of the hotel for many years. In keeping with the mission theme, the back of the postcard tells us that the dining room, "with its heavy beams and statues of Saints, is suggestive of the period when good Father Junipero Serra showered blessings on his little flock."

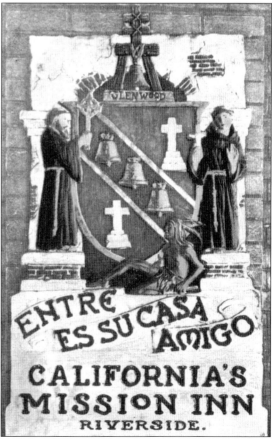

MISSION INN ESCUTCHEON, C. 1908. This escutcheon brought together many symbols of the Mission Inn, including the raincross on top, Father Serra on the left, St. Francis on the right, a California Indian below, various bells and crosses, and of course, the inn's motto, "*Entre Es Su Casa Amigo*" (Enter, this is your home, friend). Portions of this escutcheon, and the complete version, can be found throughout the hotel.

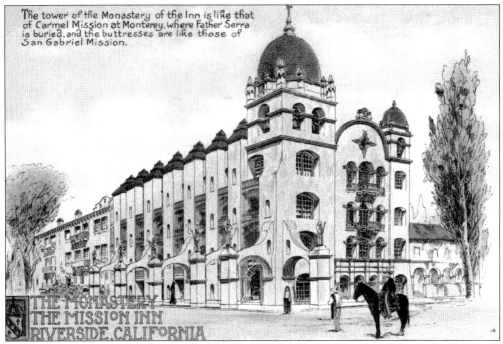

CARMEL TOWER DRAWING, C. 1911. This view is of the Cloister Wing at Sixth and Orange Streets and shows the second wing to be added to the hotel. The quote indicates that the buttresses fronting Orange Street were patterned after the San Gabriel Mission, and the Carmel Tower was inspired by the Carmel Mission Chapel. The Cloister wing was reminiscent of the many monasteries Miller visited during his trips to Europe. Some of the earliest references call this portion a monastery, as shown here.

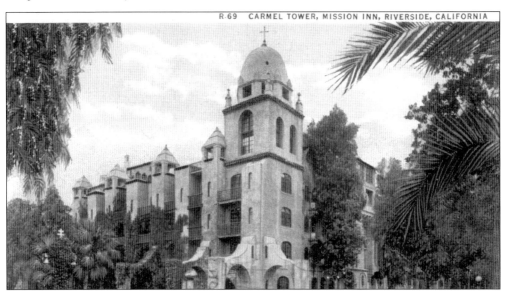

LATER VIEW OF THE CLOISTER WING AND CARMEL TOWER, 1920S. By this time more had been added to the inn, but this corner continued to charm visitors, especially those who had seen some of the original missions.

TYPICAL GUEST ROOM IN THE CLOISTER WING, C. 1910S. These rooms were rather unique because of the alcoves built into the buttresses that fronted Orange Street. Many of these contained writing desks. Additionally, most of the rooms had small balconies that overlooked Orange Street.

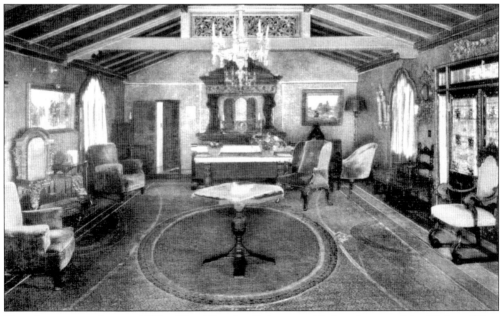

THE ALHAMBRA SUITE, 1920S. The Alhambra Suite was added to the top of the Cloister Wing in the mid-1920s. For many years, the Alhambra was the largest suite in the hotel. Constructed in a Moorish style, it had a huge fireplace and beams made of fragrant Mexican cedar. Writer Hamlin Garland spent many weeks in the Alhambra during his later years. Just outside of the Alhambra Suite is the Alhambra Garden, a part of the suite.

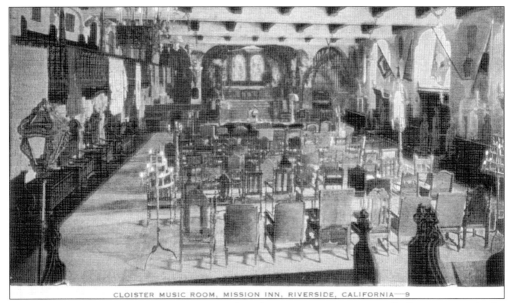

CLOISTER MUSIC ROOM, EARLY 1910S. The Cloister Music Room was the largest room in the Cloister wing, and was used as a performance and gathering place. Here, Miller's guests could partake of a recital, lecture, or small concert. From its completion until the 1950s, the St. Cecilia Wedding Chapel was located just to the left of the stage. Several weddings were performed in both the chapel and the music room.

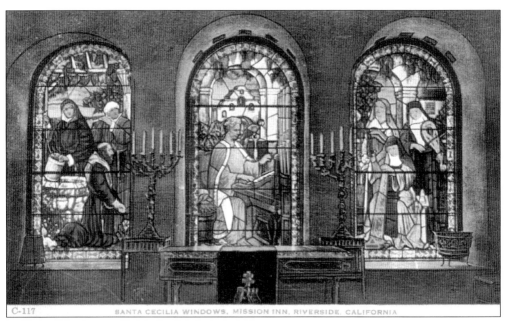

ST. CECILIA WINDOWS. At the head of the stage is this series of three windows, known collectively as the St. Cecilia windows. These windows were commissioned by Frank Miller as a memorial to his first wife Isabella, who died in 1908. They depict Isabella in the center as St. Cecilia, the patron saint of music. Also included are monks and nuns of the Franciscan Order, the Campanile from the courtyard, and the old Miller home.

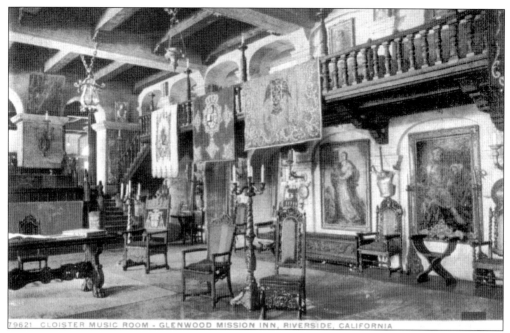

TWO VIEWS OF THE INTERIOR OF THE MUSIC ROOM, 1910S. According to early Mission Inn information, the beams in the ceiling and the minstrel gallery were copied from the San Miguel Mission and the banners on the walls were from "ancient buildings from Spain, Italy, and France." Throughout his travels abroad, Frank Miller collected an astonishing amount of, in his words, "stuff." This included paintings, tapestries, furniture, architectural implements, bells, etc. that were displayed throughout the inn, especially in the public rooms such as the Cloister Music Room.

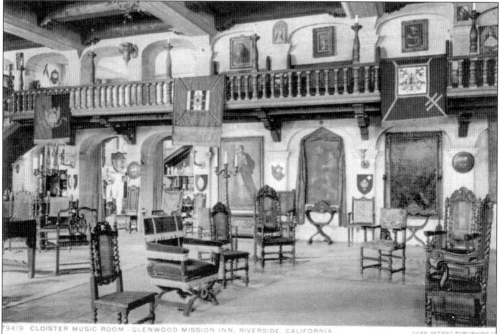

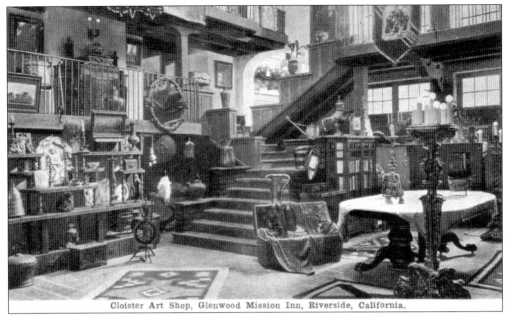

CLOISTER ART SHOP, 1920S. The Cloister Art Shop was adjacent to the music room and was the gift store of the hotel. Here, Frank Miller sold many of the antiquities procured from abroad, but for which he found no use once they arrived months later at his hotel. In addition, Miller sold stationery, post cards, booklets, and anything else upon which he could put a picture or imprint of the Glenwood Mission Inn.

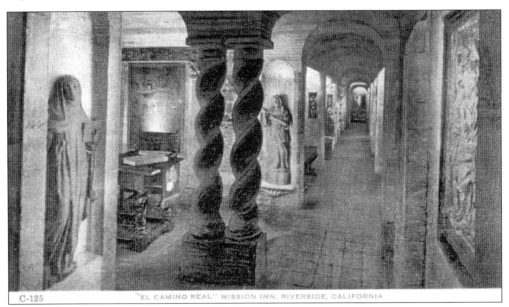

CLOISTER WALK, LATE 1910S. The Cloister Walk, later referred to as the "Catacombs" by many Riversiders, was a series of tunnels constructed under the Cloister Wing and, later, the courtyard. The Cloister Walk was used to display many more of Miller's treasures and as a place where his guests could take a stroll during inclement weather. Contrary to popular belief, they do not lead to Mt. Rubidoux or any other place outside of the Mission Inn block.

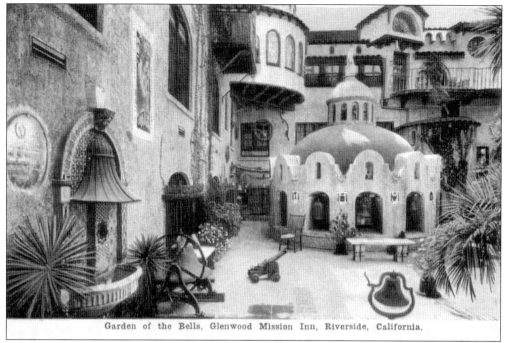

Garden of the Bells, Glenwood Mission Inn, Riverside, California.

GARDEN OF THE BELLS, 1920s. The Garden of the Bells, visible from the Spanish Patio dining area, was a sitting area that held many of the bells the Millers collected over the years. Ranging in size from just a couple of inches to objects that were much larger, the bells were a consistent attraction for many of the guests. The dome, depicted in the upper view, is said to be a copy of one from the San Juan Capistrano Mission.

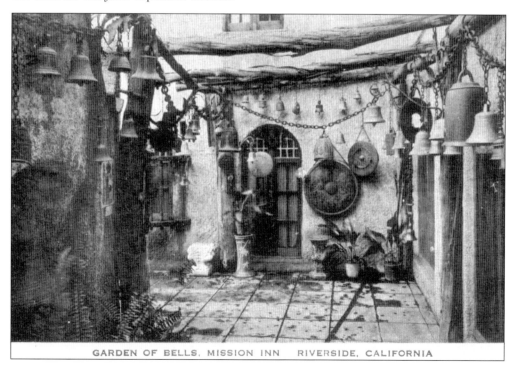

GARDEN OF BELLS, MISSION INN RIVERSIDE, CALIFORNIA

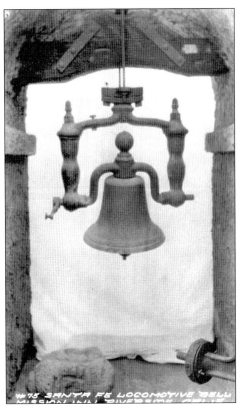

LOCOMOTIVE BELL, 1920s. According to the postcard and a Mission Inn booklet entitled "The Bells and Crosses of the Mission Inn," this was the first locomotive bell heard in Riverside. It was on the train that entered Riverside on the new Riverside, Santa Ana, and Los Angeles Railroad on December 15, 1885. How or why it was given to Frank Miller is unknown, but it still hangs in the Garden of the Bells.

OLDEST DATED BELL IN CHRISTENDOM, 1920s. By all accounts, this is the oldest dated bell in the Christian world. It is Spanish, and apparently made to honor Santiago of Compostella, or St. James, the patron saint of Spain. Inscribed inside of the bell is the date of 1247. Frank Miller purchased it from the foundry that made Big Ben in London, much to the consternation of the British Museum.

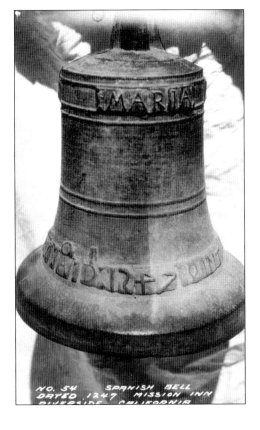

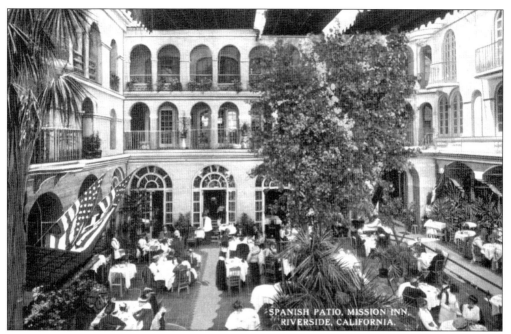

SPANISH PATIO, 1920s. This area was constructed as part of the Spanish Wing in 1914–1915, and included this outdoor dining area. The Spanish Patio offered a myriad of sites for Miller's guests, including balconies, walkways, the Garden of the Bells, and a gargoyle fountain in the center.

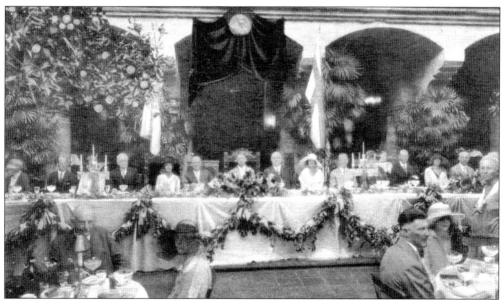

VISIT OF CROWN PRINCE GUSTAVUS ADOLPHUS OF SWEDEN, JULY 22, 1926. Crown Prince Gustavus Adolphus, together with his wife Princess Louise, toured Riverside's extensive orange groves and then dined at the inn at a banquet held in their honor. He said of his surroundings: "Of all the hotels I have visited in the United States, I never have seen one to compare with the Mission Inn." Crown Prince Gustavus later became King Gustavus VI Adolphus, reigning from 1950 to 1973.

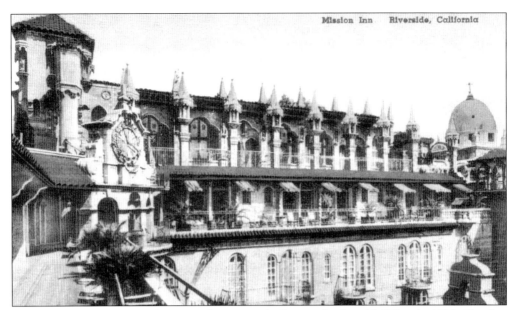

AUTHORS' ROW, 1930s. This row of suites was built atop the Spanish Wing in 1928. The five were named for authors who lived there, including Carrie Jacobs Bond ("At the End of a Perfect Day"—the song of the Mission Inn), Harold Bell Wright (*The Winning of Barbara Worth*), Zona Gale (*Frank Miller of the Mission Inn*—Frank Miller's biography), Henry Van Dyke ("God of the Open Air"—Read at Mt. Rubidoux Easter Sunrise Services), and Joseph Lincoln (*Cy Whittaker's Place*).

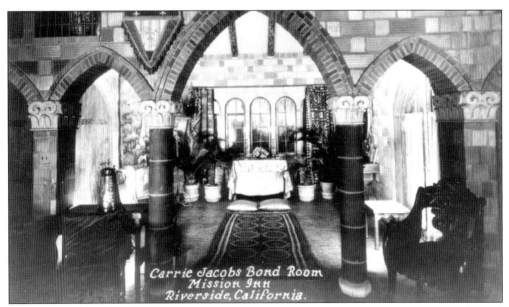

INTERIOR OF CARRIE JACOBS BOND ROOM, 1930s. The Carrie Jacobs Bond room is located at the far west end of Author's Row. Ms. Bond was a frequent visitor and resident of the hotel, and knew the Millers well. Upon returning to the hotel from an excursion up Mt. Rubidoux, she penned a poem entitled "At the End of a Perfect Day." This was later set to music and became the song of the Mission Inn.

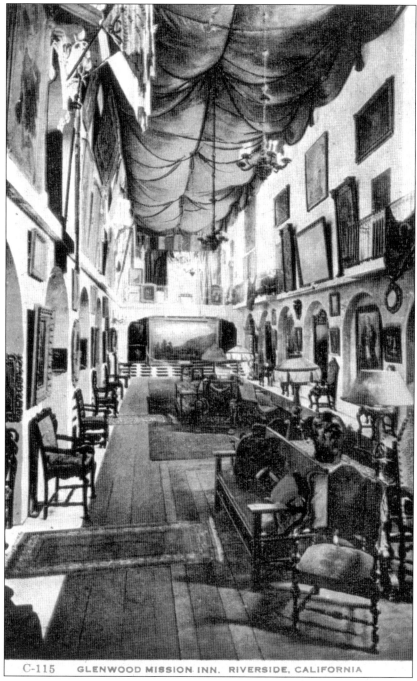

SPANISH ART GALLERY, MID-1920S. This is the Spanish Art Gallery, the largest room in the Spanish Wing. In 1914, Frank Miller added this third wing to the hotel after having visited Spain and becoming enamored with their art and architecture. The Spanish Art Gallery displayed Miller's ever-growing collection of artwork from abroad. One very recognizable artifact appears in the center of this shot—the William Keith painting entitled "California Alps," that hangs near the front desk today.

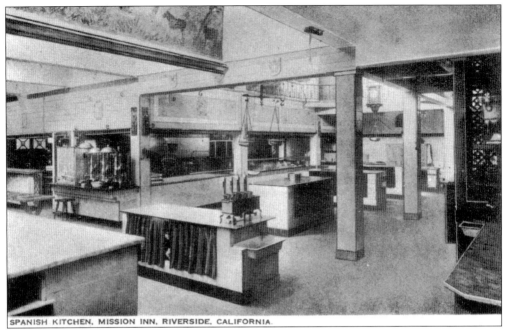

MISSION INN KITCHEN, C. 1940. Even the inn's kitchen was decorated in a manner reminiscent of the missions. In fact, the kitchen used to have a walkway for guests to view the artwork and food preparations.

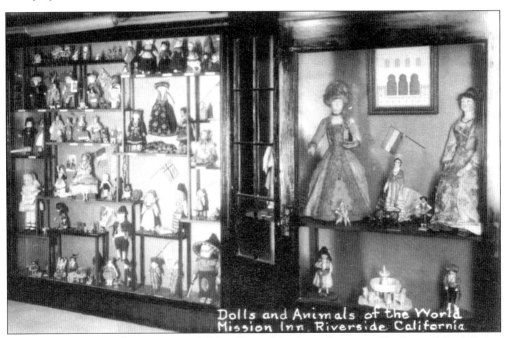

MISSION INN DOLL COLLECTION, 1930S. One of the lesser-known collections of the Mission Inn was that of the dolls. Dressed in clothing reflecting the cultures from which they came, the dolls were another source of pride for the inn's owners and one of amusement for its guests.

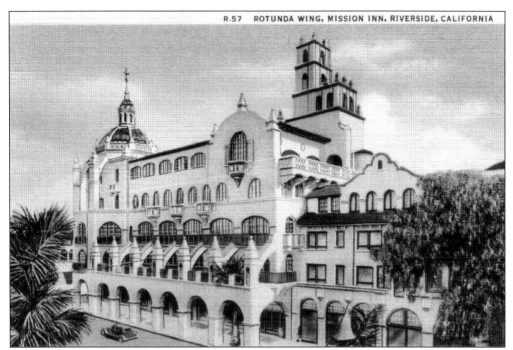

MISSION INN ROTUNDA WING. These two views, from 1932 (top) and around 1940, show the final portion of the Mission Inn—the Rotunda Wing, completed in 1931. Located at the southeast corner of Sixth and Main Streets, the Rotunda Wing completed the Mission Inn, creating a hotel that encompassed an entire block. This newest portion was designed and built by local architect G. Stanley Wilson, and may be how he is best remembered. The tiled dome seen in both pictures is the Amistad Dome, which covers the old bridal suite.

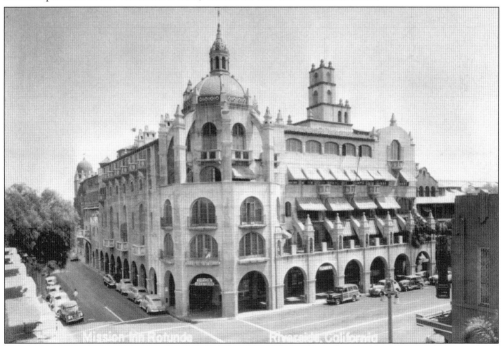

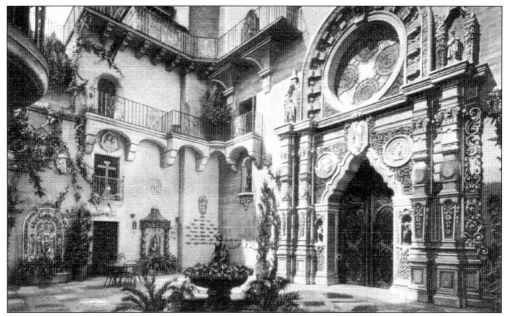

ST. FRANCIS ATRIO, LATE 1930s. This small patio area in front of the Saint Francis Chapel is the Saint Francis Atrio, part of the Rotunda Wing. The corner shown in this view displays the Flier's Wall, which pays tribute to many early aviators and aviation pioneers. The large doorway to the right is the entrance to the Saint Francis Chapel. The doors are solid wood, and their entire height of 15 feet can be opened.

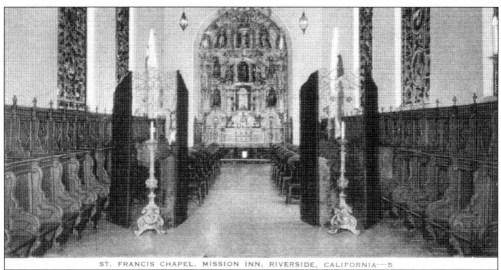

SAINT FRANCIS WEDDING CHAPEL, MID-1930s. This room is one of the best-known in the Mission Inn. Often mistaken for a church, the Saint Francis Chapel has been a wedding chapel since 1932. The Reyes Altar, dating to the 1720s, is seen in the center. In addition, several of the Tiffany windows are seen. Louis Comfort Tiffany was impressed by Frank Miller's work at the inn, and offered the windows, which Tiffany had designed and built for a church in New York, for display at the inn. Because of the size of the windows and the altar, the Saint Francis Chapel had to be specially designed to house them.

THE MISSION INN ROTUNDA, C. 1935. The Rotunda, located near the corner of Sixth and Main Streets, was designed to be the commercial portion of the inn. This structure housed several professional offices and was decorated with emblems of many countries. Its tall, winding staircase has been used for many wedding pictures and movies.

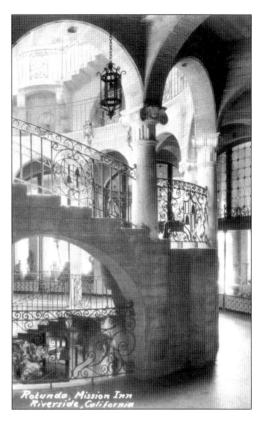

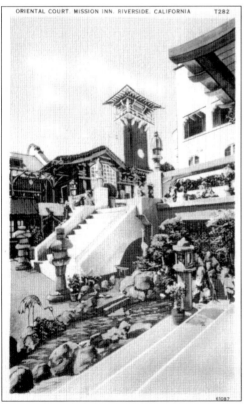

COURT OF THE ORIENT, C. 1935. In his later years, Frank Miller became interested in the art and culture of China and Japan. When he constructed the Rotunda Wing, he incorporated much Asian design into this courtyard, which housed sculptures, Japanese-style architecture, and a koi pond.

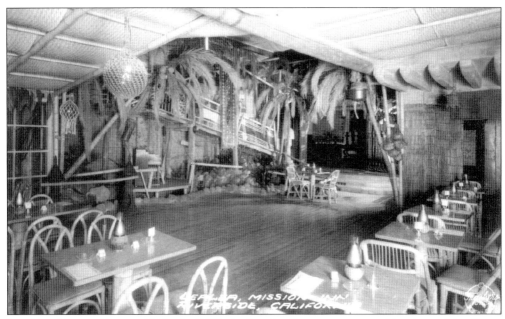

LEA LEA ROOM, EARLY 1940S. In 1939, the Lea Lea Room was created in place of the Court of the Orient. This view shows the dance floor and some of the cocktail tables. The Lea Lea Room was a very popular place among military personnel, dignitaries, and celebrities during its more than 40 years at the inn. (Courtesy of Frasher's Fotos, Pomona.)

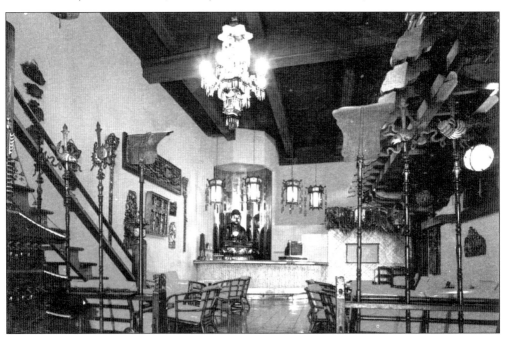

LEA LEA ROOM, 1950S. This view shows the present-day Ho-O-Kan Room as it appeared as part of the Lea Lea Room. A 19th-century Buddha watches over the bar in the far corner, as do several pieces of the inn's famed Asian art collection. The Lea Lea Room was discontinued during the renovation of the hotel in the 1980s.

Four
Mt. Rubidoux and the Santa Ana River

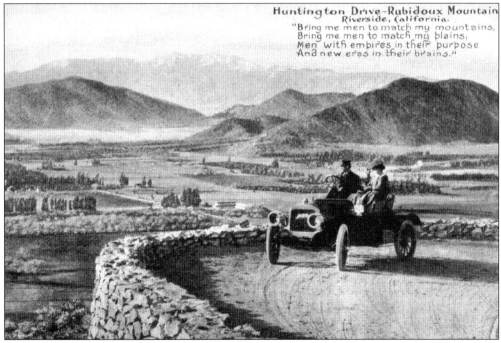

Young Couple on Automobile Trip up Huntington Drive, c. 1908. This Mission Inn souvenir postcard says it all. The quote is from "The Coming American" by Sam Foss and characterizes the attitude of Frank Miller and other early Riverside boosters. Mount Rubidoux, a geographic feature just west of downtown, was a favorite vantage point and excursion destination for early Riversiders and guests of the Mission Inn. The view is along Huntington Drive, overlooking the West Riverside area.

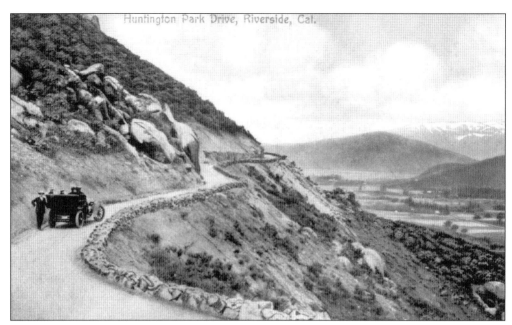

HUNTINGTON DRIVE UP MT. RUBIDOUX, LOOKING OUT TOWARD HIGHGROVE, C. 1912. Huntington Drive was named for Henry Huntington, owner of the Pacific Electric Railway Company, nephew of Collis P. Huntington, and friend of Frank Miller. As can be seen in this photo, Huntington Drive was a narrow lane. There was one way up and another way down. This side would have allowed sightseers to gaze out over the ever-expanding city of Riverside.

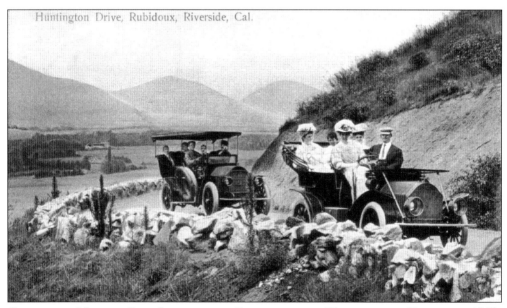

GLENWOOD MISSION INN AUTOMOBILE EXCURSION UP HUNTINGTON DRIVE, C. 1909. Frank Miller owned a fleet of Stearns Knight automobiles that he used to transport his guests up Mt. Rubidoux and around Riverside. In the years before World War I, an automobile trip was a unique adventure and probably something that few of his guests had done before. The raincross symbol is visible on the grille of the rear auto.

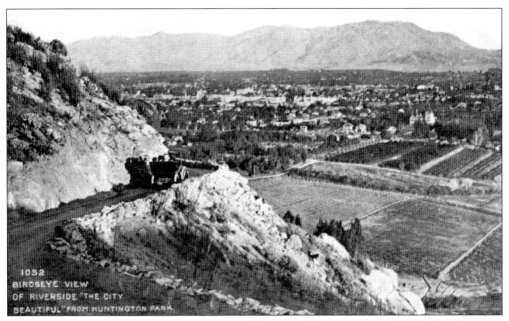

HUNTINGTON DRIVE OVERLOOKING THE CITY OF RIVERSIDE, C. 1910. Another auto excursion stops to take in the view of Riverside. Identifiable buildings include Grant School and the Riverside County Courthouse.

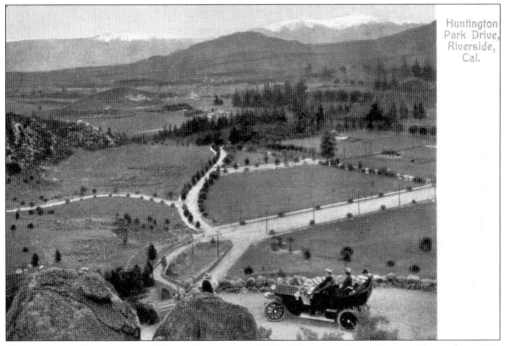

VIEW FROM HUNTINGTON PARK DRIVE, C. 1908. This view is looking northeast from Mt. Rubidoux. The straight road below is Seventh Street, just as it begins to go around Mt. Rubidoux. The shrub-lined curved street coming off of it is Mt. Rubidoux Drive. Perhaps one of the excursionists pictured here built some of the stately homes that exist there today.

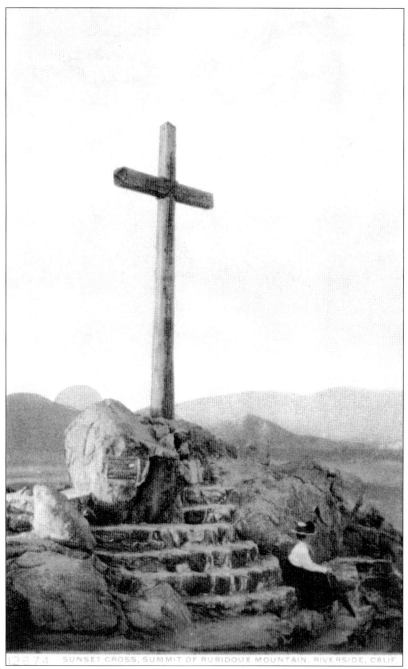

SERRA CROSS ATOP MT. RUBIDOUX, C. 1920. The Serra Cross, named in honor of Father Junipero Serra, was erected and consecrated atop Mt. Rubidoux on April 26, 1907, at the behest of Frank Miller. This cross, although replaced a few times over the years, has been a Riverside landmark since then. A series of high stone steps takes one to the base of the cross, where there is a plaque dedicated to the Franciscan padre who founded many of the Spanish missions in Southern California. A persistent (but incorrect) story has it that Father Serra himself visited the Riverside area.

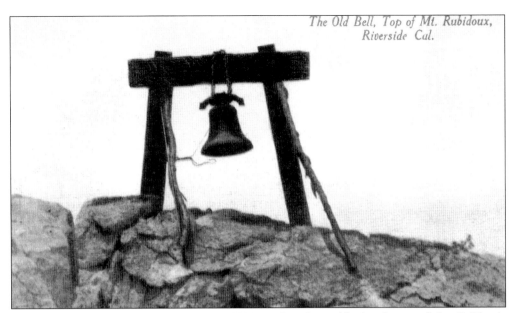

OLD BELL ATOP MT. RUBIDOUX, C. 1912. In keeping with the theme of the California Missions and the Serra Cross, it was fitting that Frank Miller would place a "Mission Bell" atop the mountain for his guests to view. Although Riverside never played host to any of the Spanish missions, it did not stop boosters like Miller from capitalizing on the mission theme in any way they could.

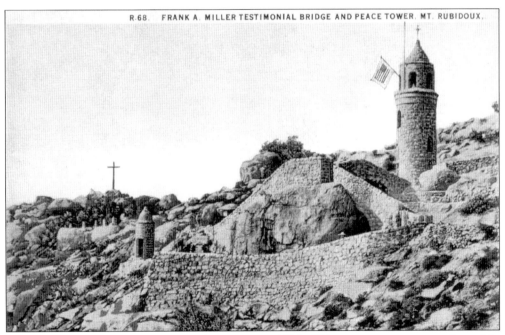

PEACE TOWER AND FRIENDSHIP BRIDGE, C. 1928. This structure was erected on Mt. Rubidoux in 1925 by various Riversiders and other friends of Frank Miller who dedicated it to him for his work toward international peace and friendship. It was constructed while Miller was on a trip to the Orient to foster a better understanding of China and Japan.

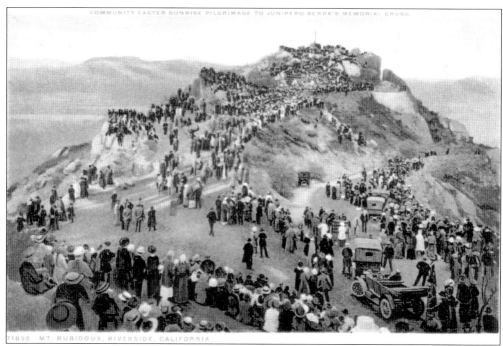

EASTER SUNRISE SERVICES ATOP MT. RUBIDOUX, C. 1918 (TOP) AND MID-1920S (BOTTOM). The Easter Sunrise Service has been a regular event atop Mt. Rubidoux since its inception on April 11, 1909. The inspiration came from early social reformer Jacob Riis. Henry Van Dyke, a writer and frequent guest at the Mission Inn, wrote a poem entitled "God of the Open Air," which he read on at least two occasions. In early years, it was custom for those congregated atop Mt. Rubidoux to adjourn to breakfast at the Mission Inn after the services.

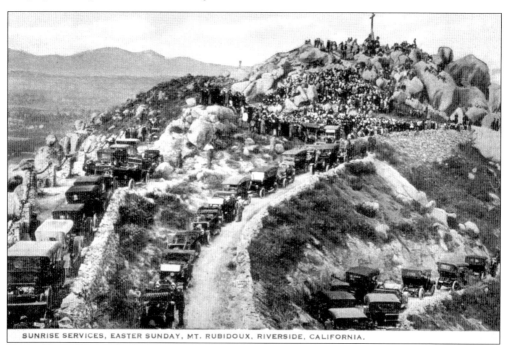

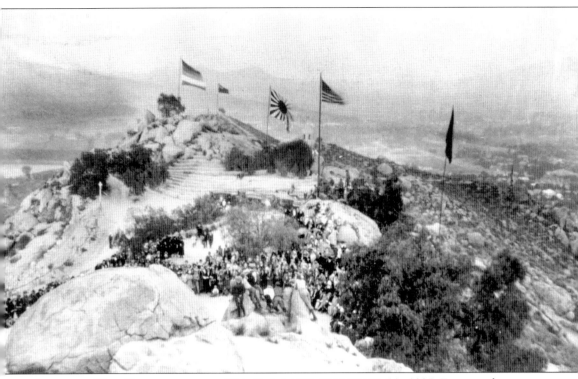

ARMISTICE DAY CELEBRATION ON MT. RUBIDOUX, NOVEMBER 11, 1925. For several years, Riversiders gathered on the smaller northernmost peak of Mt. Rubidoux to acknowledge Armistice Day, the anniversary of the end of the Great War (World War I). The sender of this postcard indicated that he and others spent the entire morning at this event.

TOP VIEW OF 1906 STONE BRIDGE OVER SEVENTH STREET, C. 1910. This small bridge connected Mt. Rubidoux and Little Mt. Rubidoux, spanning Seventh Street (later Buena Vista Drive).

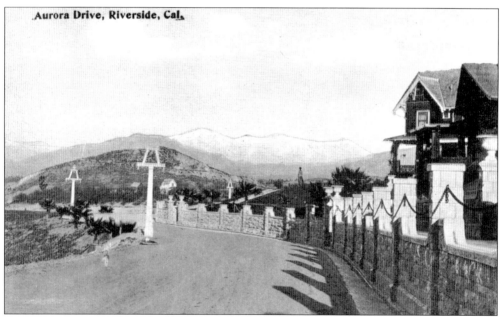

AURORA DRIVE, C. 1908. Aurora Drive was and is home to many stately houses on the northern side of Mt. Rubidoux. The road was constructed in 1906, but in 1916 the name was changed to Rubidoux Drive West. Due to confusion between that name and others, in 1954 the street name was changed to Indian Hill Drive to commemorate the Indian village that once existed there.

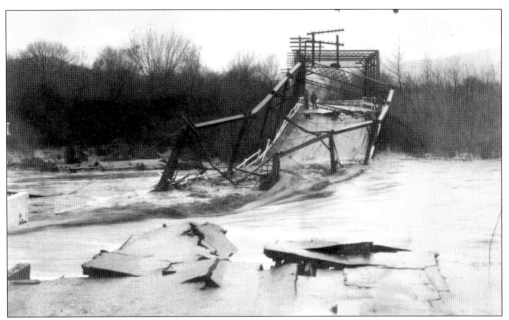

SANTA ANA RIVER BRIDGE WASHOUT, 1916. This view shows the devastation wrought by the Santa Ana River upon the bridge between Riverside and West Riverside in 1916. Many people today chastise Riverside for not having a true river, but few realize the tremendous amount of water that the Santa Ana River contained before extensive pumping and damming brought a certain level of control to it.

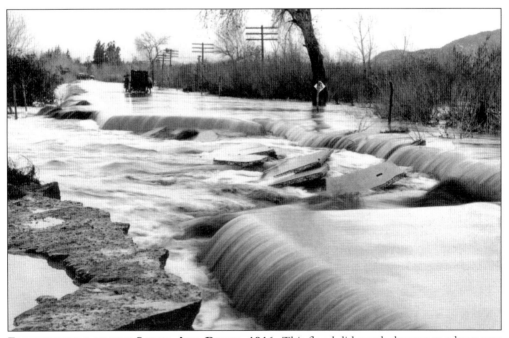

FLOODWATERS OF THE SANTA ANA RIVER, 1916. This flood did much damage to a large area around Riverside and West Riverside. After episodes such as the one above, Riversiders would often be cut off from their neighbors to the north and west for weeks, if not months.

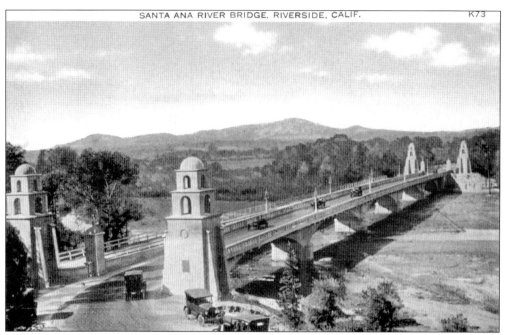

MISSION BRIDGE ACROSS THE SANTA ANA RIVER, MID-1920S. In 1923, the County of Riverside constructed a reinforced concrete bridge to connect Riverside with West Riverside. At the behest of several Riversiders, most notably Frank Miller, the bridge towers were constructed in the Mission style, and the entire span of the bridge sported the raincross symbol.

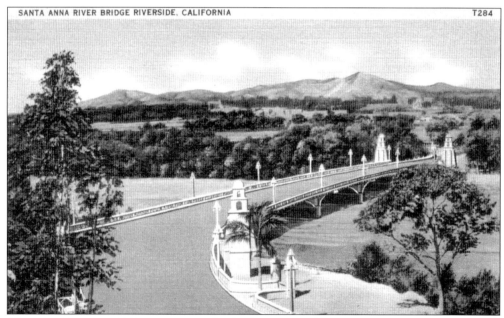

MISSION BRIDGE, 1930S. In 1931, the bridge was widened as shown in this later view from the original bridge that consisted of barely one lane. This bridge, however, was severely damaged in the flood of 1938, and was eventually removed in 1958 when the present bridge was constructed.

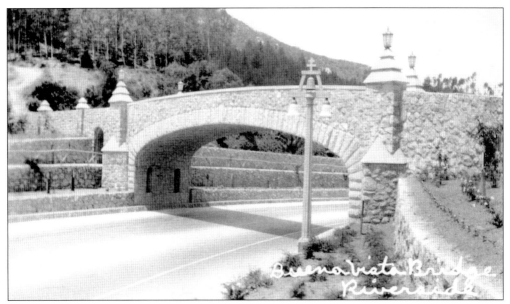

BUENA VISTA BRIDGE, C. 1931. In 1930–1931, as part of an overall beautification project for the city's west entrance, the Mission-style Santa Ana River Bridge was widened, and Buena Vista Drive was improved as seen in these views. As part of this beautification, the 1906 stone bridge over the drive was replaced by the one in the view above.

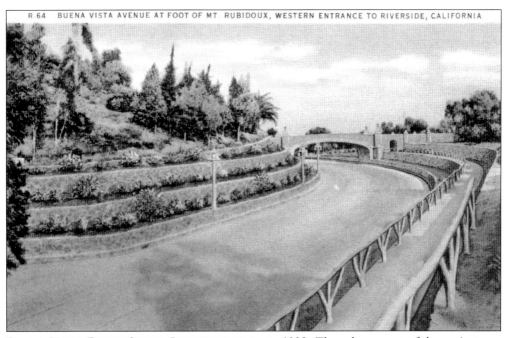

BUENA VISTA DRIVE STONE IMPROVEMENTS, C. 1932. The other aspect of the project was the addition of the stonework and raincross symbols, which were extended between the two bridges, as seen in this view. Thus, a visitor to Riverside entering from the west was treated to several civic-minded improvements as he wound his way around Mt. Rubidoux along Seventh Street toward downtown.

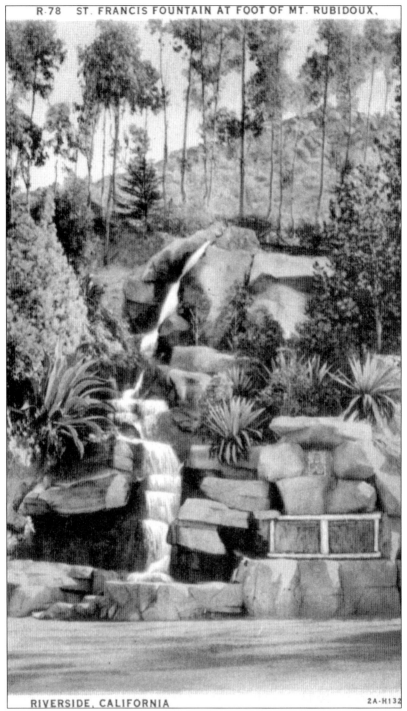

St. Francis Shrine/Fountain, 1932. The St. Francis Shrine/Fountain was dedicated on June 16, 1916, and was sponsored by both the Audubon and Humane Societies. Charles Loring gave most of the necessary money. This structure and set of plaques were visible from the Santa Ana River bridge, and greeted visitors to Riverside coming in from West Riverside.

Five
MAGNOLIA AND VICTORIA AVENUES

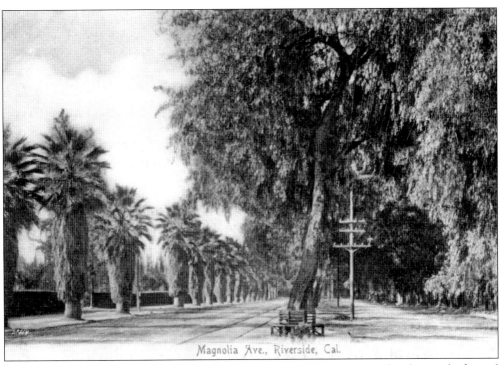

MAGNOLIA AVENUE, C. 1903. Magnolia Avenue was laid out in 1876 by the newly formed Riverside Land and Irrigating Company. They had just acquired nearly 15,000 acres of land that stretched from the present-day La Loma Hills near Grand Terrace all the way down to the Temescal Hills. The southern portion of the holdings, though, south of present-day Arlington Avenue, was virtually undeveloped and not generally accessible to potential investors. This was solved by constructing Magnolia Avenue through the undeveloped lands.

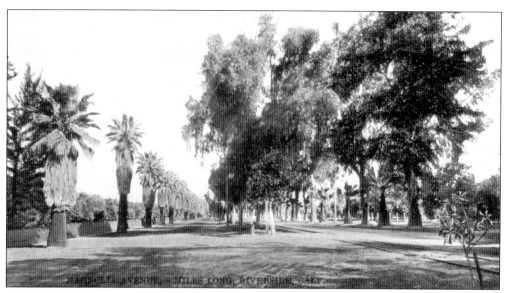

MAGNOLIA AVENUE, C. 1910. This long thoroughfare, Riverside's showcase, was originally named Bloomingdale Avenue, but soon changed to Magnolia Avenue. Magnolia Avenue was to be 132 feet wide. Of that, 82 feet were to be used by two lanes, 10 feet for a landscaped median strip between them, and two 20-foot landscape strips on both sides. This grand boulevard would be a showcase for potential investors who could travel the pleasant trip by carriage and later by automobile, all the while viewing the orange groves and vacant lands waiting to become orange groves and homes.

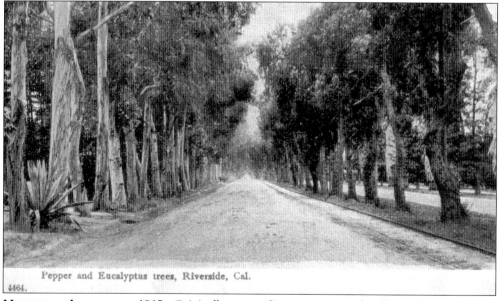

MAGNOLIA AVENUE, C. 1915. Originally, magnolia trees were to be the predominant plant along Magnolia Avenue, but it was soon discovered that they required a great amount of water and were very expensive. Therefore, other trees such as eucalyptus, palm, and pepper were used extensively since they are better suited to Riverside's drier climate. Magnolias were planted at the intersections of major streets.

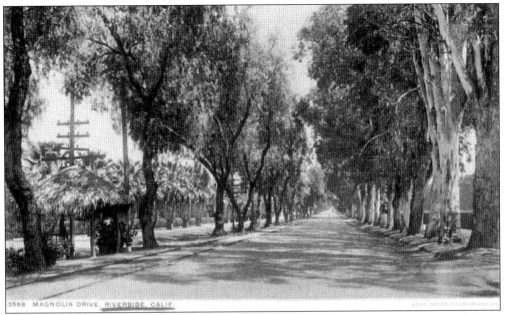

MAGNOLIA AVENUE, C. 1910. Because of the length of Magnolia Avenue, it was natural that a railroad would be combined into the right-of-way, as seen here. The rails went along the southern lane of Magnolia Avenue and were originally used by horse-drawn trolleys. These later gave way to electric trolleys. Many old postcard views of Magnolia Avenue show park benches or small huts that operated as stopping points along the route.

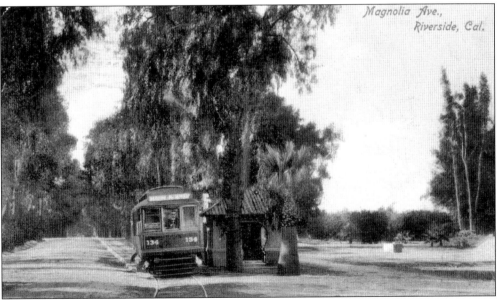

MAGNOLIA AVENUE LOOKING SOUTH FROM ARLINGTON AVENUE, C. 1900–1902. For many years, Magnolia stopped at Arlington Avenue. This meant that the road had to veer east and head north along Brockton Avenue into Riverside. Today, the area just to the right of the small enclosure is occupied by the park that houses the Parent Navel Orange Tree, planted there in April 1902.

INTERSECTION OF MAGNOLIA, BROCKTON, AND CENTRAL AVENUES, C. 1930. This view is looking northwest with Magnolia Avenue in foreground, Brockton to the left, and Central crossing the view. Stewart's Auto Court and Gas Station is visible on the left, with Gilmore Gasoline on the right.

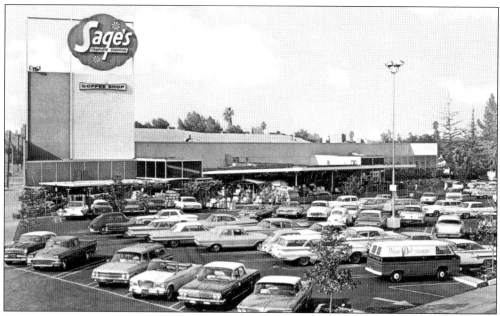

SAGE'S COMPLETE SHOPPING, C. 1960. Sage's is fondly remembered by longtime Riversiders as a friendly place to shop. The Magnolia Center store shown above, on Beatty Avenue between Magnolia and Brockton Avenues, was built around 1947 and was the main Riverside store. Two others were located downtown and in the Hardman Center. Sage's filed for bankruptcy in 1973, and its stores closed soon after.

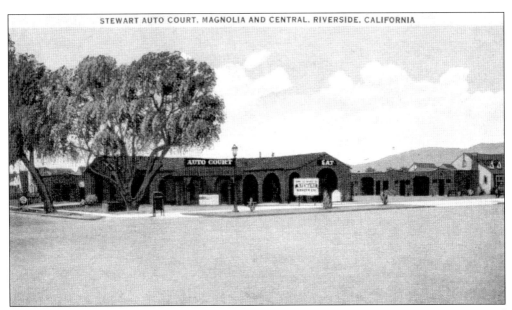

STEWART'S AUTO COURT, C. 1930. This combination auto court, restaurant, gas station, and real estate office was owned and operated by Luther P. Stewart from 1929 to 1933. Located at the northwest corner of Brockton and Central Avenues, Stewart's Auto Court offered a simple place to stay and eat for weary tourists wanting to stay "out in the country." In 1934, it became the Traveler's Rest Auto Court (see below).

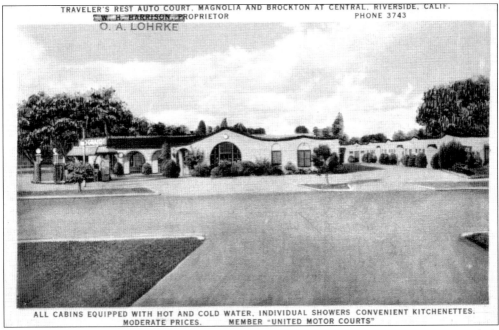

TRAVELER'S REST AUTO COURT, C. 1936. The successor to Stewart's Auto Court, Traveler's Rest Auto Court, was in business from 1933 to about 1948 under a long list of owners, including William Harrison, Otto Lohrke, and Adolph Van De Merwe. The Traveler's Rest Auto Court was eventually demolished to make way for other commercial uses.

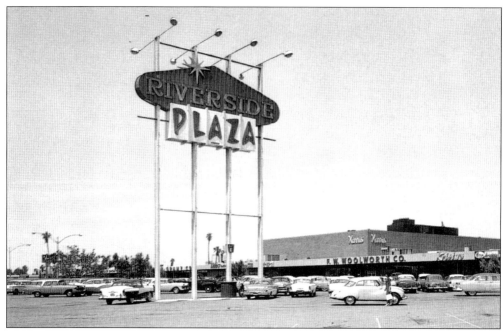

RIVERSIDE PLAZA AND SIGN, LATE 1950S. The Riverside Plaza opened in three phases between June 1956 and October 1957 and solidified the replacement of Riverside's core shopping area from downtown to a more suburban setting. Touted as the largest shopping mall within a 100-mile radius, the Plaza, developed by Heers Associates, featured 200,000 square feet of floor space, three elevators, and the first escalators in Riverside.

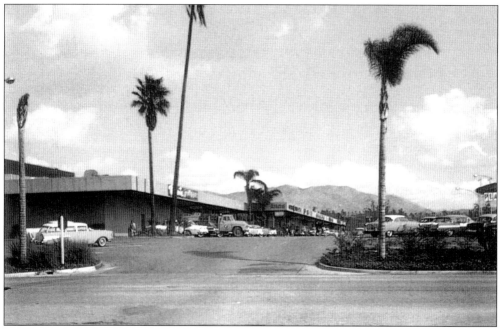

RIVERSIDE PLAZA LOOKING EAST, LATE 1950S. The old Rexall Drug Store is visible in the foreground of this shot, taken to show Riverside's new "modern" shopping location.

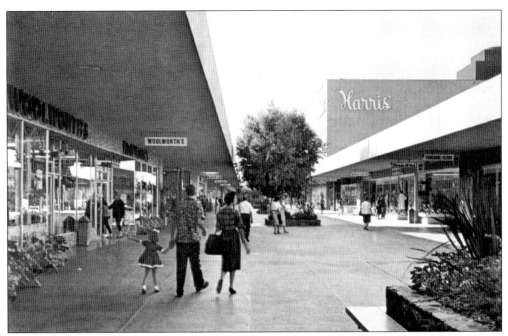

RIVERSIDE PLAZA, INTERIOR VIEW, EARLY 1960S. Many Riversiders may still remember the original open-air plaza as shown in this picture. Note the Woolworth's Store on the left and Harris' on the right. The plaza was enclosed in the early 1980s.

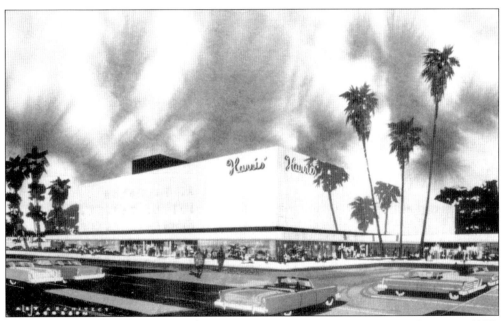

PROMOTIONAL POSTCARD, HARRIS' NEW RIVERSIDE PLAZA STORE, SUMMER 1957. Riversiders considered it quite special to have San Bernardino-based Harris' expand to Riverside. When the store opened on September 30, 1957, it boasted of not only the latest in fashion but also an appliance department, separate fountain coffee shop, and an auditorium available for use by civic groups.

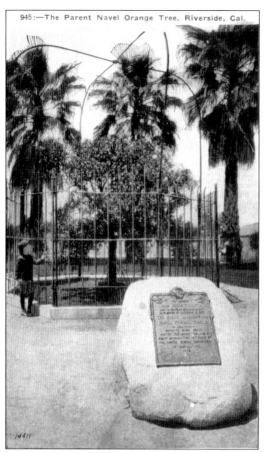

PARENT NAVEL ORANGE TREE PARK, 1910s. Eliza Tibbetts planted two trees that became known as the Parent Navel Orange Trees. After her death, one tree was given to the city and the other to the Riverside Pioneer Historical Society. On April 23, 1902, the city planted its tree in this park, located at the southwest corner of Magnolia and Arlington Avenues. Soon afterward, an iron fence had to be erected to keep people from cutting buds.

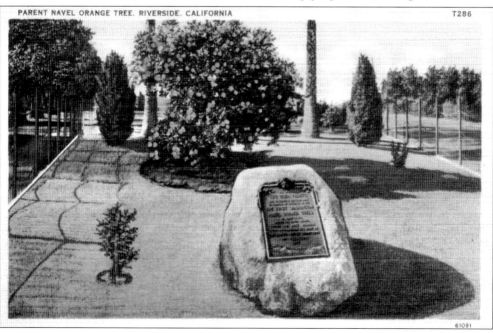

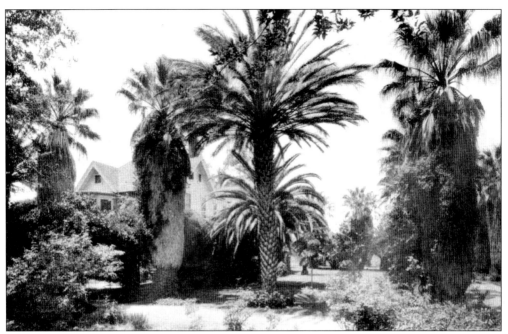

ORIGINAL NEIGHBORS OF THE WOODCRAFT HOME, EARLY 1920S. The Neighbors of the Woodcraft was a fraternal organization established like a long-term life insurance program. Members would pay in, and (possibly) be able to live out their elder years in the care of the Neighbors of the Woodcraft. These buildings were located on Magnolia Avenue between Adams and Monroe.

ORIGINAL NEIGHBORS OF THE WOODCRAFT HOME. These two buildings, including a home and other structures, and the 45 acres surrounding it were purchased in 1920 for use as a retirement home. The two houses soon proved to be inadequate, and a new building plan was established

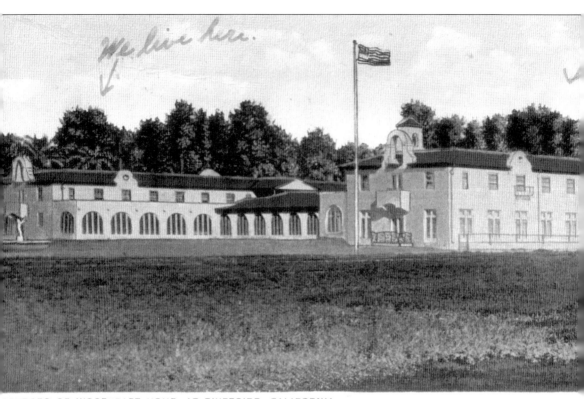

PANORAMA OF THE NEW NEIGHBORS OF THE WOODCRAFT HOME, LATE 1920S. This series of much larger buildings was the result of fund-raising by the organization and the architectural work of Henry Jekel. Built in 1926, the new Neighbors of the Woodcraft home boasted of many individual rooms and became a focal point for the organization. Constructed in the Mission style,

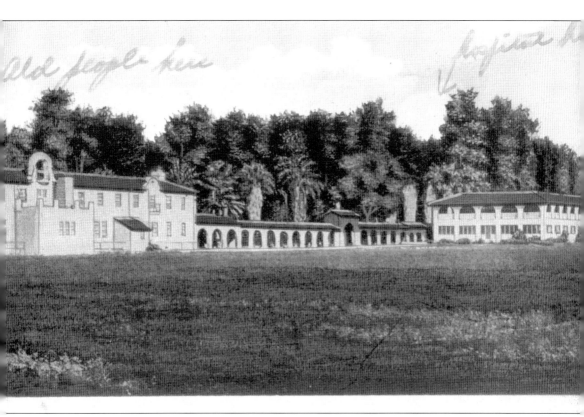

probably at the behest of Mission Inn owner Frank Miller, this complex existed for nearly 30 years. In the mid-1950s it was sold and converted to California Baptist College, the predecessor of today's California Baptist University.

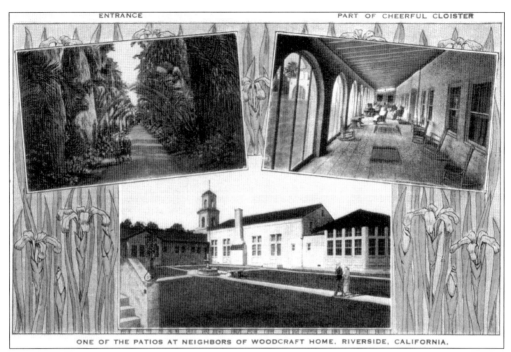

Relaxation Amenities, Neighbors of the Woodcraft Home, Late 1920s. This shows the heavily landscaped entryway, which had been part of the original home, the "cheerful cloister," and one of the outside patios that could be enjoyed by residents.

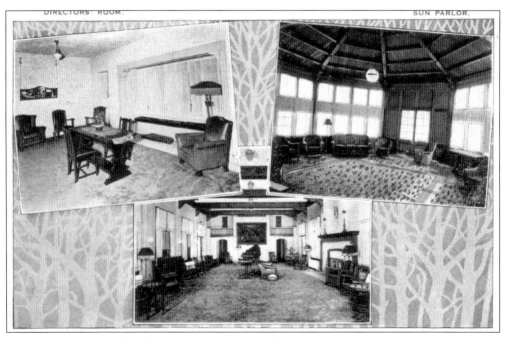

Director's Room, Sun Parlor, and Living Room, Neighbors of the Woodcraft Home, Late 1920s. Postcards such as these helped tremendously in fund-raising efforts for groups such as the Neighbors of the Woodcraft.

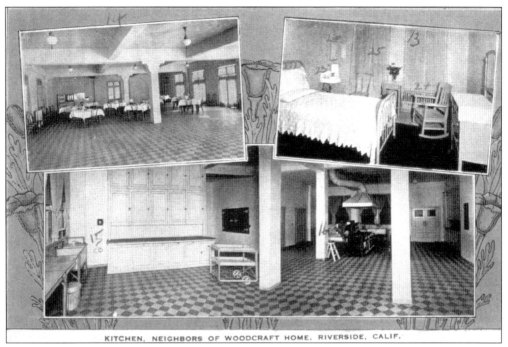

DINING ROOM, KITCHEN, AND TYPICAL BEDROOM, NEIGHBORS OF THE WOODCRAFT HOME, LATE 1920S.

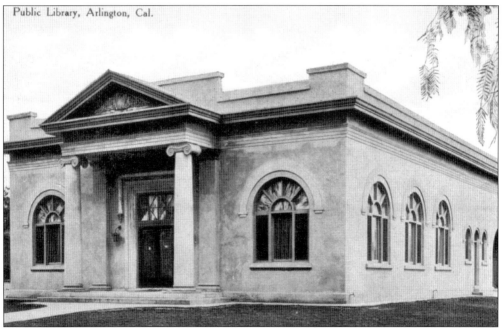

ARLINGTON LIBRARY, C. 1912. The Arlington branch library was the first branch of the Riverside library system. This building, designed in the Neoclassical style by local architect Seeley Pillar, was opened on June 1, 1909, and is still in use today as Riverside's oldest library building. It was remodeled in 1927–1928 by another local architect, G. Stanley Wilson.

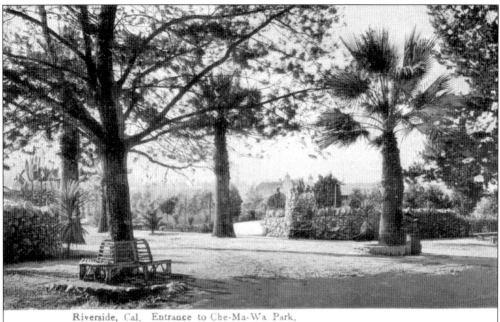

Riverside, Cal. Entrance to Che-Ma-Wa Park.
6668.

CHEMAWA PARK ENTRANCE ON MAGNOLIA AVENUE, C. 1905. Chemawa Park was an early entertainment venue, featuring a zoo, polo ground, dance pavilion, and roller skating rink. Named in 1901 for the Chemawa Indian School in Oregon, Chemawa Park lasted nearly 30 years. In 1928, the Riverside School District purchased the property and soon after built and opened Chemawa Junior High School, which is today called Chemawa Middle School.

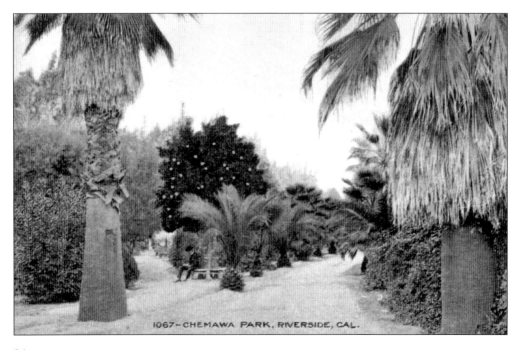

1067~CHEMAWA PARK, RIVERSIDE, CAL.

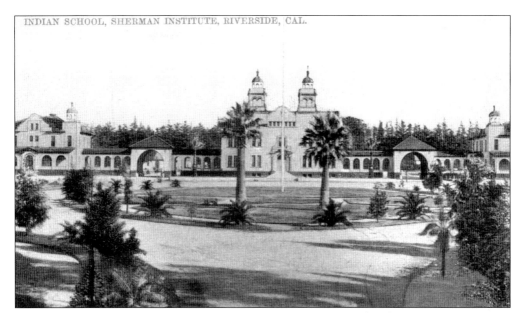

MAIN ENTRANCE TO SHERMAN INDIAN INSTITUTE, C. 1910. The Sherman Indian Institute was brought to Riverside by an act of the U.S. Senate dated May 31, 1900, which made it possible to move the 10-year-old Perris Indian Industrial School to Riverside. Named for James Schoolcraft Sherman, chairman of the Committee on Indian Affairs in the House of Representatives, the Sherman Institute opened on September 8, 1902, as the 25th non-reservation boarding school nationwide.

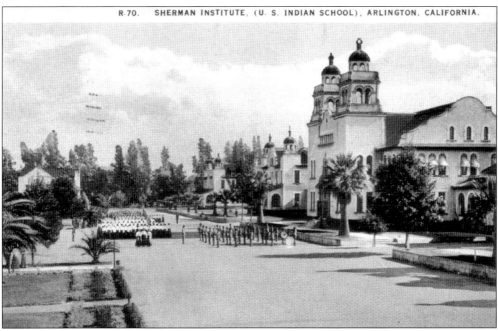

SHERMAN INDIAN INSTITUTE REVIEW PARADE, 1920S. In its early days, the Sherman Indian Institute was hailed as one of the most progressive institutions for "civilizing" the native population. Here, the students are marching past a crowd (doubtless some of the administrators)

95

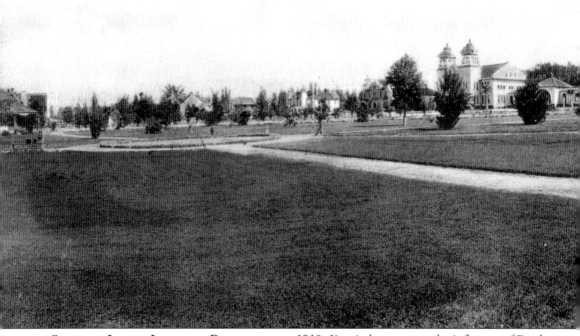

SHERMAN INDIAN INSTITUTE PANORAMA, C. 1910. Due in large part to the influence of Frank Miller, the Sherman Institute was constructed in Mission-revival architecture. Most of the

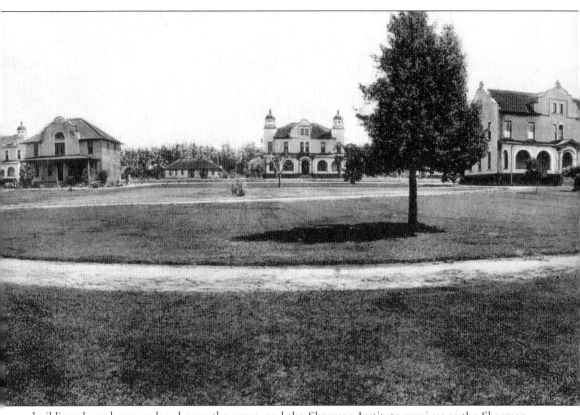
buildings have been replaced over the years, and the Sherman Institute survives as the Sherman Indian High School.

INTERSECTION OF MAGNOLIA AVENUE AND VAN BUREN BOULEVARD IN ARLINGTON, C. 1910. Arlington was a "town within a town," and had its own business district and post office, all the while being within the incorporated boundaries of the City of Riverside. Originally planned in 1874 as a separate colony town, Arlington became the hub of a vast citrus-growing region.

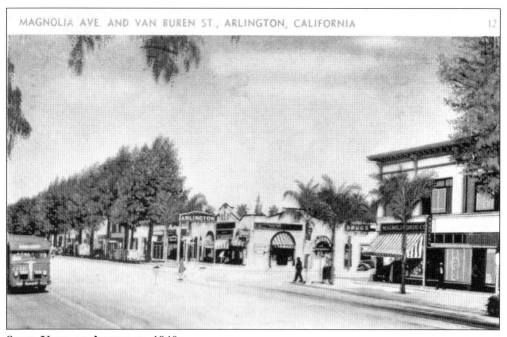

SAME VIEW AS ABOVE, C. 1940.

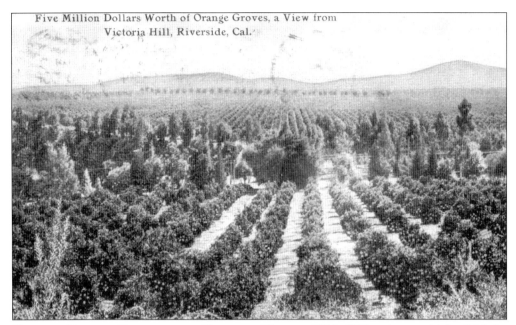

VIEW OF ORANGE GROVES FROM VICTORIA HILL, C. 1911. "What do you think of this for orange groves?" writes the sender of this postcard, referring to the $5,000,000 in trees shown in this view. It was quite common for visitors to Riverside to be overwhelmed by the sheer acreage devoted to orange groves. Many of them wrote to their loved ones in the Midwest and East Coast to tell them about the bounty.

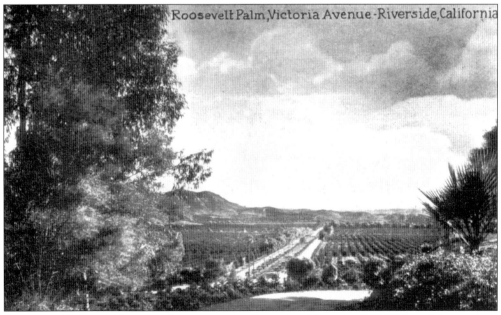

ANOTHER VIEW OF ORANGE GROVES FROM VICTORIA HILL, C. 1910. This and the previous view show the extent of citrus development in the Arlington Heights region of Riverside from Victoria Hill. This photo clearly shows Victoria Avenue as it leads straight through Arlington Heights.

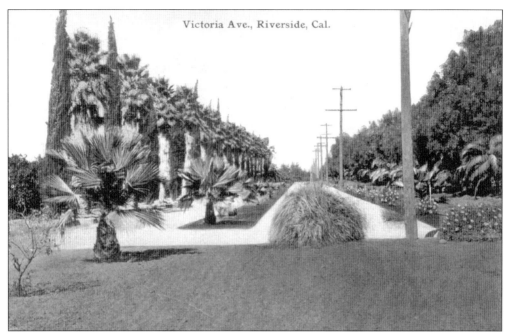

VICTORIA AVENUE, C. 1905. Victoria Avenue was Riverside's second major divided thoroughfare. Planted with palm trees, Italian Cypress, and several other "exotic" plants, it soon became another of Riverside's major tourist attractions.

VICTORIA AVENUE, C. 1912. Victoria Avenue was laid out in 1892 and was meant to connect Matthew Gage's newly developed Arlington Heights area to the downtown business district of Riverside. Initially, the avenue terminated at present-day Myrtle Street at the base of Victoria Hill, but it would soon be continued around the hill.

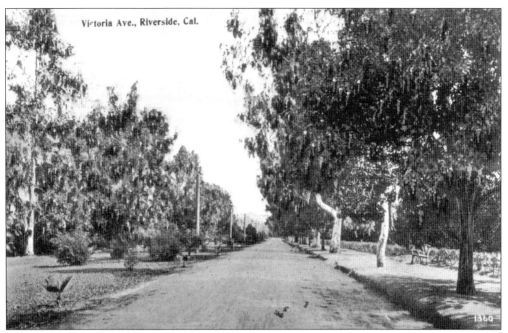

VICTORIA AVENUE, 1910s. The writer of this card, telling his mother in Michigan of the sights in Riverside, told her that "it is beautiful here, and we will have to go some to see half of it!"

VICTORIA AVENUE, 1920s. There was, of course, another side to Victoria Avenue, and that was real estate. Like Magnolia Avenue, Victoria Avenue was meant to open the wide tracts of land subdivided as Arlington Heights to agricultural development. Town leaders obliged, encouraging day trips via horse and carriage, or later, automobile to view the prospects Riverside had to offer.

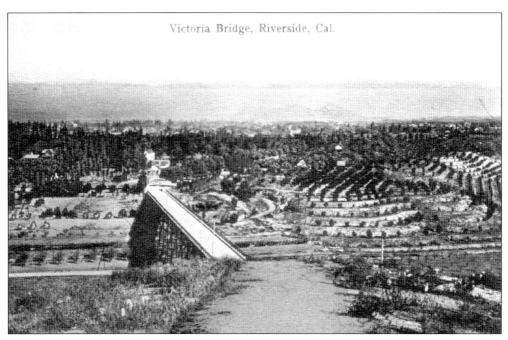

VICTORIA BRIDGE, C. 1910. In order to connect Victoria Avenue with the city's eastside region and eventually downtown, the Tequesquite Arroyo had to be bridged. In 1891, the wooden bridge, shown here looking north from Victoria Hill, was constructed. The wooden bridge eventually fell into disrepair, and a new concrete and steel bridge was constructed in 1928, which is the present-day Victoria Bridge.

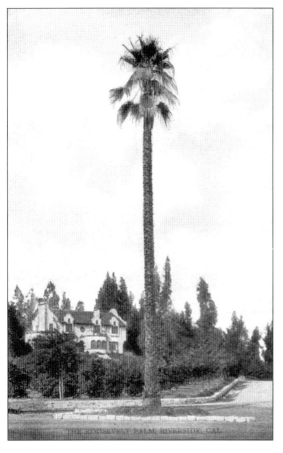

ROOSEVELT PALM, C. 1905. One of the many events scheduled for president Theodore Roosevelt during his overnight visit to Riverside on May 7–8, 1903, was the dedication of this commemorative palm tree. For many years this tree stood at the base of divided Victoria Avenue until it was moved a few feet west to its present location. This view is looking west from the intersection of Victoria Avenue and Myrtle Street.

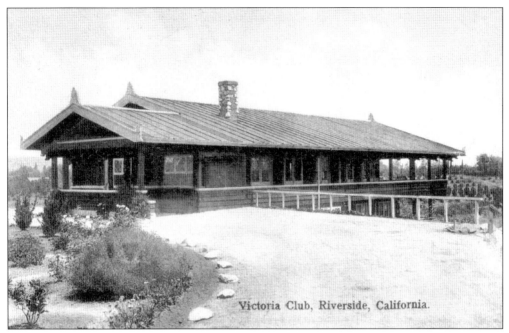

ORIGINAL VICTORIA CLUB BUILDING, C. 1908. The Victoria Club was founded in 1903 by several of Riverside's elite. Located at the base of Victoria Hill and the edge of the Tequesquite Arroyo, the Victoria Club began as a golf course–oriented country club. This building was designed by Franklin Pierce Burnham and opened early in 1904. Although the Victoria Club still exists, this building was removed several years ago.

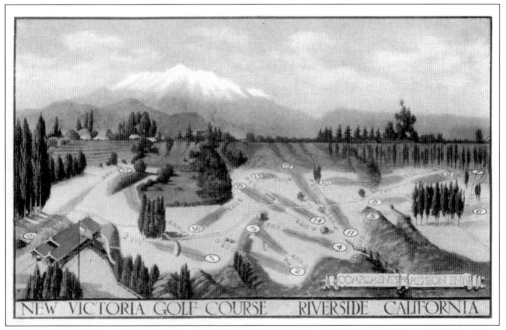

SCORECARD DEPICTING THE GOLF COURSE AT THE VICTORIA CLUB, C. 1910. This view is from the south looking north with the original clubhouse building depicted at the bottom left.

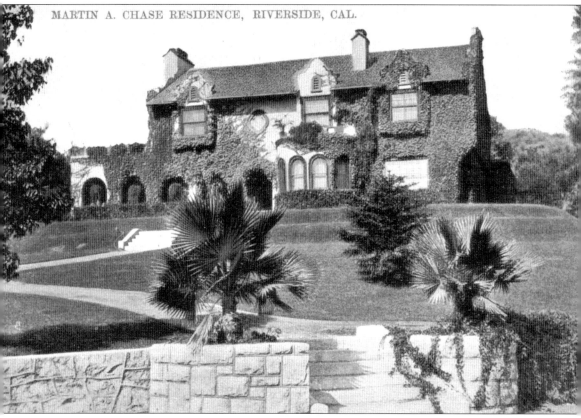

MARTIN CHASE HOUSE, C. 1910. This large home is located on Myrtle Avenue just west of Victoria Avenue and is one of the earliest Mission-style buildings in Riverside. It was built in 1901 by Martin Chase (part owner with his father Ethan Allen and brothers Harry and Frank of the Chase Nursery Company), the Chase Rose Company, and the National Orange Company. Martin Chase and his wife lived in the home until his death in 1913.

Six
OTHER VIEWS

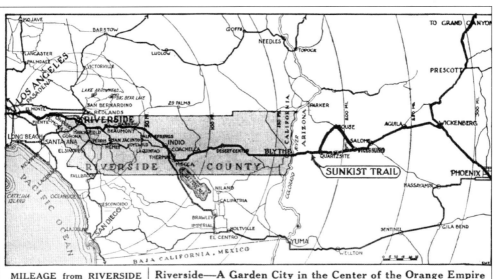

MILEAGE from RIVERSIDE	Riverside—A Garden City in the Center of the Orange Empire
Phoenix, via Blythe . . 427 Phoenix, via Yuma . . 471 Palm Springs 57 South Coast Beaches . 58 Los Angeles 56	Set like a jewel amidst the eucalypti, peppers, palms and orange groves of the Santa Ana river valley, surrounded by picturesque hills, midway between Los Angeles, the desert, the mountains and the beaches, Riverside is the ideal place in which to bring up a family and to enjoy the outdoor life of sunny California. Write RIVERSIDE CHAMBER OF COMMERCE.

RIVERSIDE CHAMBER OF COMMERCE ADVERTISING CARD, 1920S. The back of this card sums up Riverside's various attractions in one sentence—"Tourists seeking the beauty and romance of Spanish days always visit Riverside. A few days at the Mission Inn, a trip to the Father Serra Cross, and the World Peace Tower on Mt. Rubidoux, a drive around Lake Evans and over Magnolia or Victoria Avenues, a visit to the Sherman Indian Institute, March Field, Citrus Experiment Station, Cactus Garden and the Parent Navel Orange Tree will be a fitting introduction to California."

GREETING POSTCARDS FROM RIVERSIDE, ALL C. 1910. The four cards on these two pages show some of the many ways people sent greetings to friends and loved ones from Riverside. Some of them are humorous, some admonish the recipient to write back, and others show some of the bountiful citrus harvest that could be seen in Riverside. Although one could not write as much on a postcard as in a letter, postcards were visual souvenirs of travels to far off lands, as those in the eastern regions of the United States considered much of Southern California.

A TOURIST'S GREETING
Well, here I am in RIVERSIDE, CAL.,
Enjoying its sights and its cheer,
Every thing's great and I'm feeling first rate
But Oh how I wish you were here.

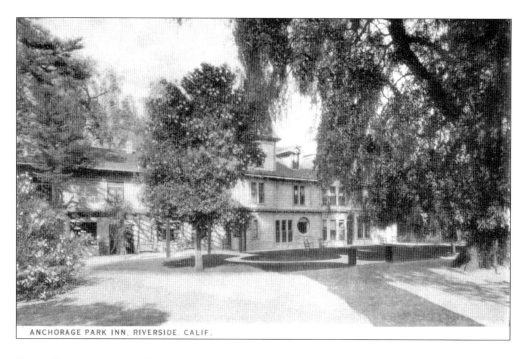

ANCHORAGE PARK INN, RIVERSIDE, CALIF.

FOUR SCENES OF THE ANCHORAGE PARK INN AND GROUNDS, 1915–1920. The inn was developed around the home of Riverside pioneer Ebenezer Brown. Brown and Dr. James Greves had been the first of John North's contingency to view the land that would become Riverside. Once established, Brown filed for approximately 100 acres of land about a half mile northeast of Riverside (about where the I-215/60 interchange is today), and here built his home, which he

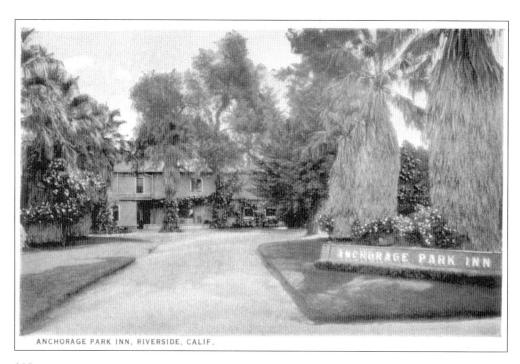

ANCHORAGE PARK INN, RIVERSIDE, CALIF.

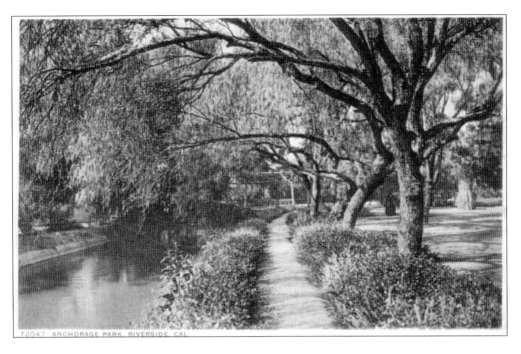

called "the Anchorage." Soon afterward he established an orange grove and nursery, and expanded the home into a small hotel. He landscaped the grounds, which included the Riverside Upper Canal (used as a centerpiece of the grounds). In 1890, it was said that 30 people could be accommodated. By the Depression of the 1930s, the hotel closed.

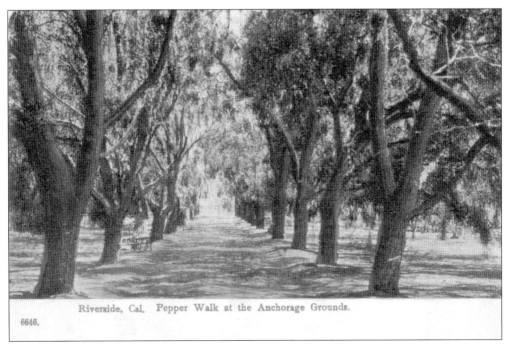

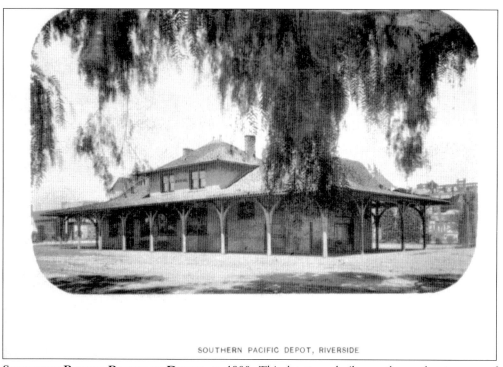

SOUTHERN PACIFIC DEPOT, RIVERSIDE

SOUTHERN PACIFIC RAILROAD DEPOT, C. 1900. This depot was built near the southeast corner of Seventh and Market Streets in 1898, and represented the culmination of nearly 15 years of effort by the Southern Pacific to enter the city of Riverside. This station would go on to serve not only the Southern Pacific, but also the Riverside & Arlington Electric Railway and the Pacific Electric system.

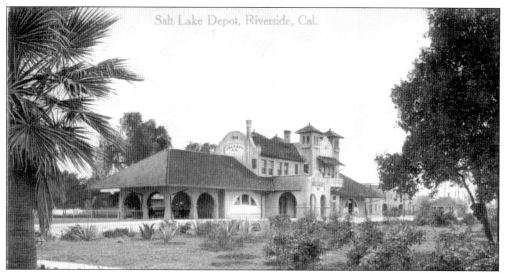

SAN PEDRO, LOS ANGELES, AND SALT LAKE CITY RAILROAD DEPOT, C. 1905. The building was constructed in 1904 when the newly formed railroad came through Riverside. Popularly known as the Salt Lake Route, this line was eventually incorporated into the Union Pacific. The building still stands on Vine Street between University and Mission Inn Avenues, but it was severely damaged in an arson fire and refurbished a few years later.

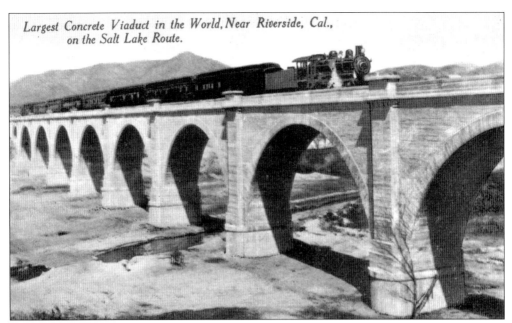

BRIDGE OF THE SAN PEDRO, LOS ANGELES, AND SALT LAKE CITY RAILROAD, C. 1909. This bridge, resembling the Roman aqueducts, was built in 1904 and spanned the Santa Ana River around what is today called Anza Narrows. As shown in these views, it was touted as the longest concrete bridge in the world. It is still visible today, and used extensively by the Union Pacific Railroad.

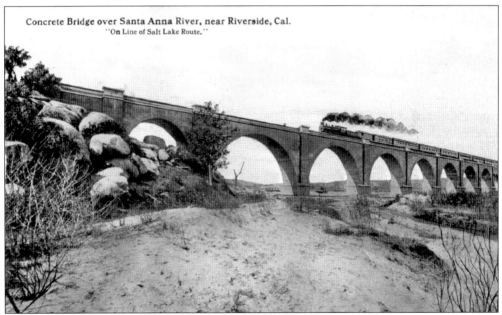

BRIDGE OF THE SAN PEDRO, LOS ANGELES, AND SALT LAKE CITY RAILROAD, C. 1915. William Pedley, who gave his name to the community across the river, assisted with engineering work for this bridge. The fact that it spanned the Santa Ana River, and was partly in quicksand, made construction of the bridge difficult.

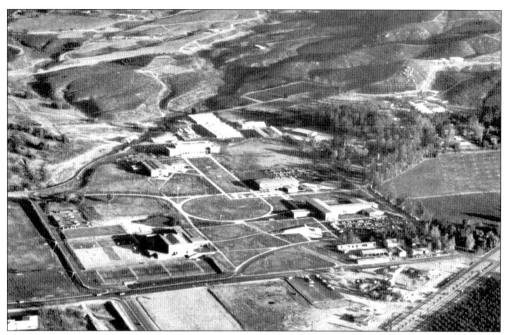

AERIAL VIEW OF THE RIVERSIDE CAMPUS OF THE UNIVERSITY OF CALIFORNIA, MID-1950S. This view is looks to the southeast. The main campus buildings shown are still on campus today, including Webber Hall (just left of center), the geology building, the library, the physical education building, and the H-shaped present-day Watkins Hall.

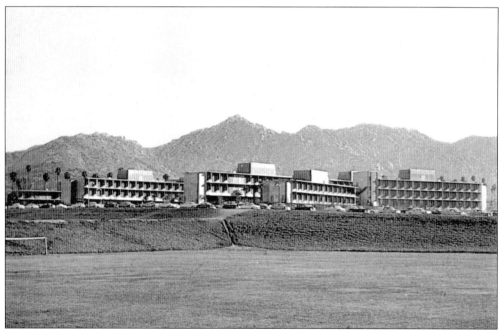

ABERDEEN AND INVERNESS STUDENT HOUSING BUILDING, C. 1960. This building was UCR's first dormitory, and was constructed in 1959. Although the building is very large, the rapid growth of UCR has made it necessary to add several more dorms over the years.

STUDENTS AT UCR, MID-1950S. Members of one of the first classes at UCR congregate by present-day Watkins Hall, looking toward the old library building.

THE BARN AT UCR, EARLY 1960S. In 1955, the old barn building that had been part of the original Citrus Experiment Station was opened to students of UCR. It became a central meeting place for drinks, conversation, and bands both local and otherwise. The Barn, long a mainstay for UCR students, was closed several years ago.

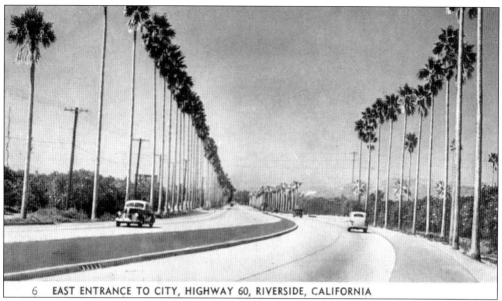

EAST ENTRANCE TO RIVERSIDE, C. 1940. This view looks west along Eighth Street (Highway 60 then), which was the city's main eastern entrance for several years. In this view, the black car on the left is beginning the ascent up the Box Springs grade to Moreno Valley. The median strip ends in the lower center of the picture at approximately the present-day intersection of Iowa and University Avenues.

EIGHTH STREET LOOKING WEST FROM CHICAGO AVENUE, C. 1955. At this time many homes still existed along Eighth Street/Highway 60, and Chicago Avenue was the city's eastern boundary. Soon after this photo was taken most of this view would change through the addition of small motels, restaurants, and more traffic.

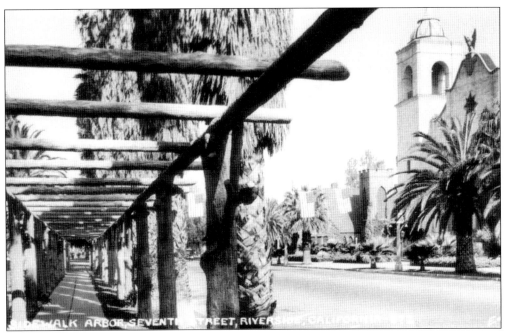

CEMENT PERGOLA ON SEVENTH STREET, 1930s. Frank Miller sought to connect the train stations at Seventh and Vine with his Mission Inn via a pergola (arbor) so that newly arrived guests could stroll to his hotel if they wanted. He almost got his wish, but some blocks went without the structure. Portions of the Pergola still exist today.

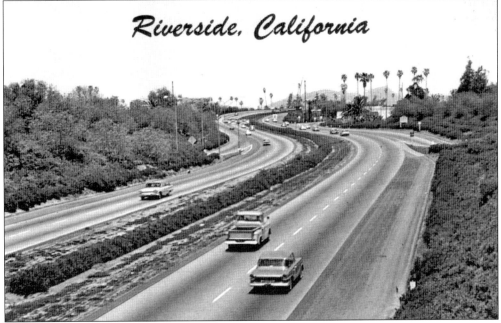

91 FREEWAY, LOOKING NORTH FROM FOURTEENTH STREET OVERCROSSING, C. 1960. The 91 Freeway, Riverside's largest, has far fewer cars on it in this photo than today. Note the exit sign for Eighth Street, now University Avenue.

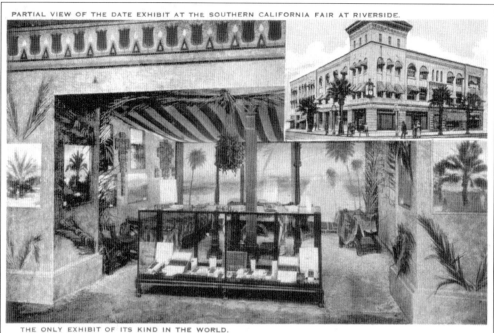

PARTIAL VIEW OF THE DATE EXHIBIT AT THE SOUTHERN CALIFORNIA FAIR AT RIVERSIDE.

THE ONLY EXHIBIT OF ITS KIND IN THE WORLD.

DATE EXHIBIT AT THE SOUTHERN CALIFORNIA FAIR IN RIVERSIDE, SEPTEMBER–OCTOBER, C. 1925. Along with the navel orange industry, another large agricultural commodity in Riverside County was dates. Although date trees were advertised in Riverside in the 1880s, the date did not thrive in town but in the Coachella Valley some 90 miles away.

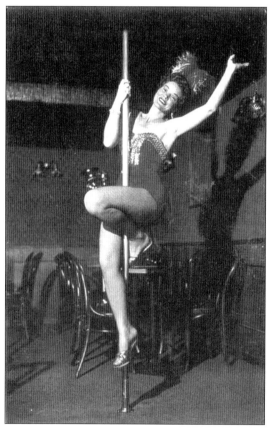

DIAMOND LIL'S, 1950S. Diamond Lil's was a cocktail lounge/nightclub located in the Loring building at Seventh and Main Streets during the 1950s. According to this postcard, Diamond Lil's "vividly brings to life and recreates just for you the vibrant charm of the Gaslight era of the Gay 90's." During its heyday, Diamond Lil's hosted such acts as the Ink Spots.

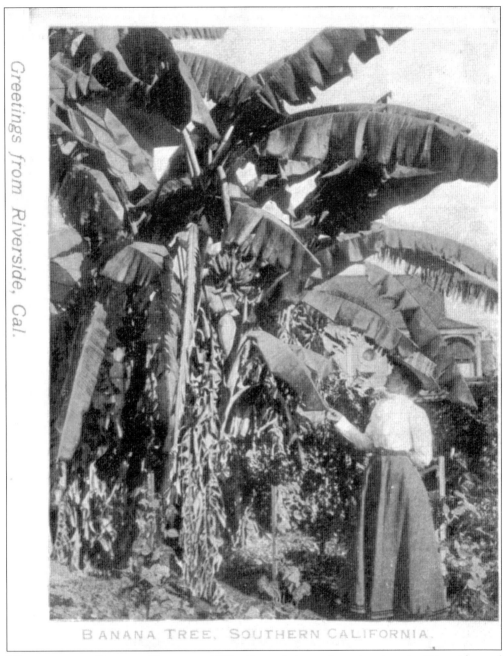

WOMAN WITH BANANA PALM, C. 1903. One of the major attractions to Riverside, and Southern California in general, is the "tropical climate." In this scene, an Edwardian woman stands next to a banana palm, symbolizing Riverside's weather as one of mild winters. Many visitors to the area were fascinated by the variety of different plants that could be grown and/or cultivated here.

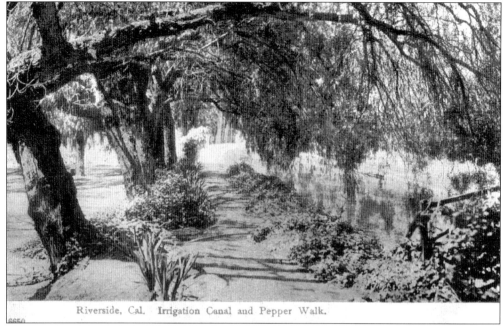

PEPPER WALK AND IRRIGATION CANAL, C. 1905. Another of the ways Riversiders attracted others to their town was to advertise the water system, which literally brought the wealth to Riverside. Postcards such as this one conveyed the fact that Riverside bloomed in what was considered a desert to most people who visited during the early years.

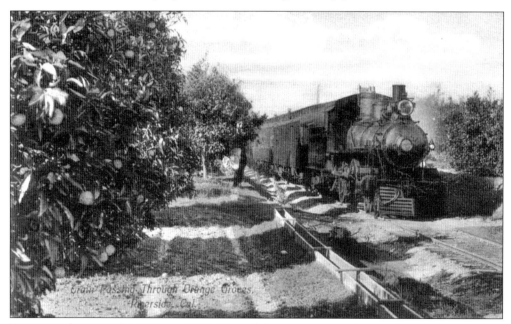

TRAIN IN ORANGE GROVES, C. 1910. One of the greatest attractions in the area was to take a train ride through the orange groves, especially when they were in bloom. Many routes, both auto and train, purposefully took tourists through the orange groves to show them off, and, more importantly, to give dazed tourists the opportunity to invest in Riverside.

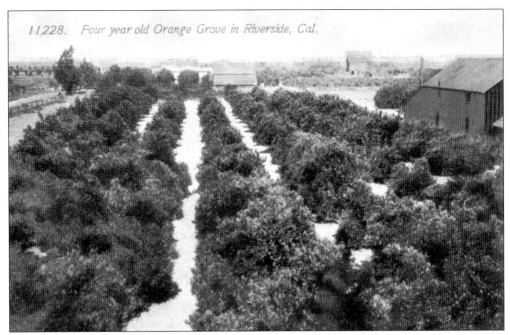

ORANGE GROVE, C. 1910. This card was directed at the potential investor who could view from afar a four-year-old grove. Many of these types of postcards were sent throughout the nation in an attempt to garner investment in Riverside land and orange groves.

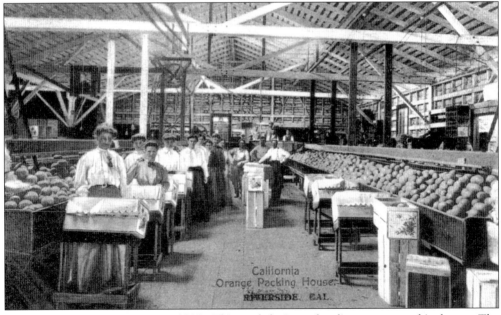

ORANGE PACKING HOUSE, C. 1905. This card depicts a bustling orange packinghouse. The industry surrounding the growing of oranges was interesting to early potential visitors to Riverside. They may have seen the end product—namely, the crates of oranges—but cards such as this and the others on these pages took them on a tour of how oranges went from grove to packing house to train and, eventually, to markets back east.

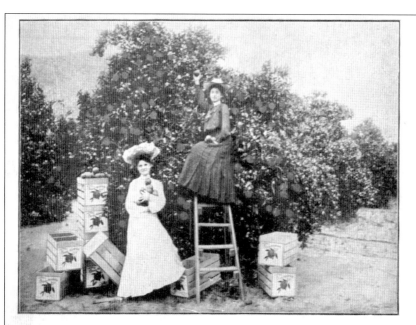

LADIES IN ORANGE GROVE, C. 1910. Even in Edwardian times sex sold, and several scenes such as this one would show women of the day situated in orange groves.

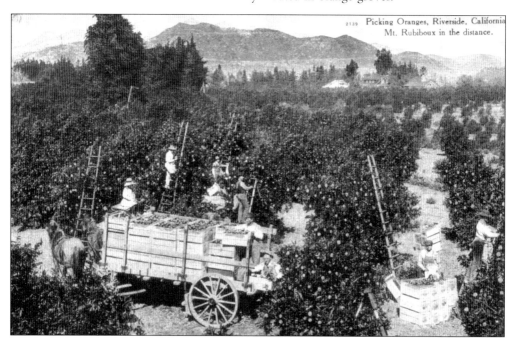

PICKING ORANGES, C. 1910. Unlike the previous scene, this one better illustrates just how oranges were picked in the early years. Massive horse-drawn wagons, huge crates, and large gangs of men positioned in the trees depicted the true nature of orange picking. Note Mt. Rubidoux in the background of this scene.

Seven
Close Neighbors

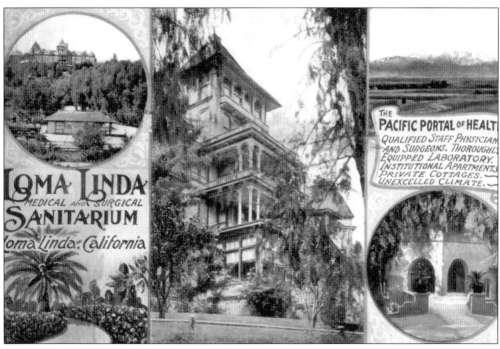

LOMA LINDA SANITARIUM, C. 1910. Originally built as the Mound City Hotel, this building was purchased in 1900, renamed Loma Linda, and used as a health-oriented hotel. The scheme failed in 1904, and in 1905 the property was purchased by the Seventh-Day Adventist Church and converted into a sanitarium and nursing school. This was the beginning of the Loma Linda University we know today.

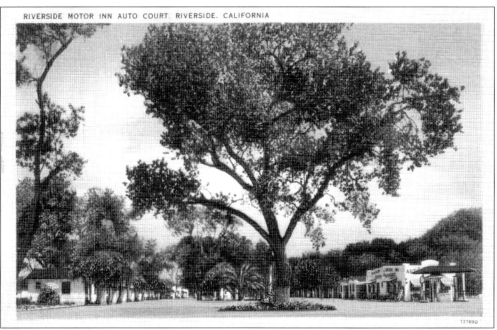

RIVERSIDE MOTOR INN, LATE 1920S. This small auto court was in West Riverside on what is now Mission Boulevard. "It is 'Just like Home' and visited by tourists; shady grounds and picturesque settings make it enjoyable" boasts the postcard.

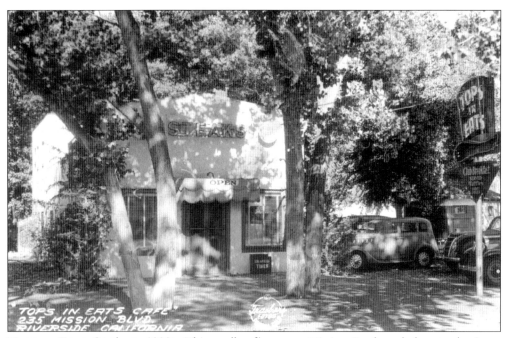

TOPS IN EATS CAFÉ, C. 1930S. This small café was on Mission Boulevard close to the Santa Ana River in West Riverside. Mission Boulevard was the main highway into Riverside from the west, and as such it was dotted with small restaurants and auto courts starting in the 1920s. (Courtesy of Frasher's Fotos, Pomona.)

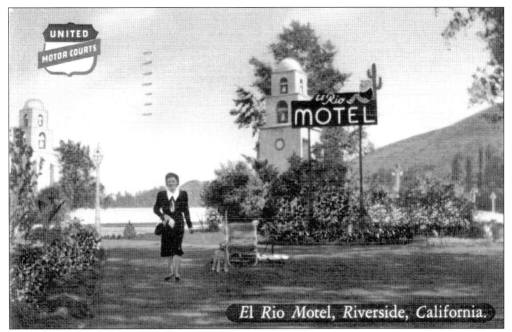

EL RIO MOTEL, LATE 1940S. The El Rio Motel was situated on the south side of Mission Boulevard at the Santa Ana River in West Riverside (note the columns of the Mission Bridge). Floyd Redman established the motel around 1946. It went through a succession of owners before it closed sometime in the mid-1950s.

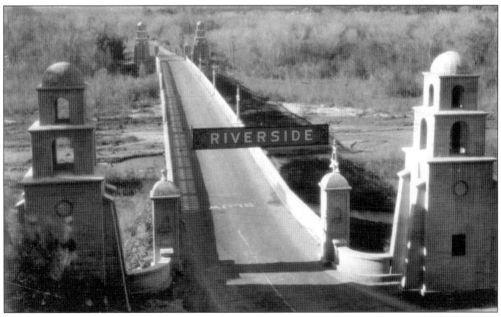

VIEW OF MISSION BRIDGE AND WEST RIVERSIDE FROM MT. RUBIDOUX, C. 1928. One may get a sense of just how sparsely populated the West Riverside area was at the time of this photo. Aside from a few houses and scattered businesses along the way, the traveler leaving Riverside would have had to drive to Ontario to be in the next major town.

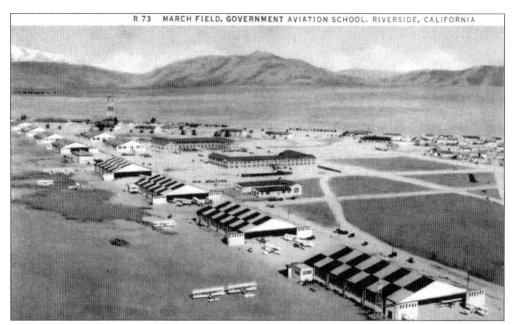

MARCH FIELD, C. 1932. Originally known as the Alessandro Aviation Field for its location on the old Alessandro town site, the facility was soon renamed for Lt. Peyton C. March, son of Gen. Peyton C. March, who had been killed in an early aviation accident in Texas. March Field was an important aviation school throughout its early years, and would later become known as March Air Force Base.

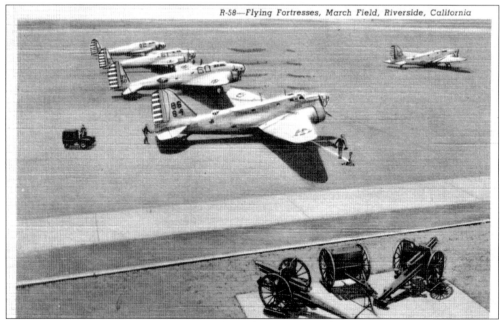

PLANES AT MARCH FIELD, C. 1940. With an obvious eye to the coming war, this card remarks that "The Government's wide flung defense program marks March Field as an important link in our chain of Coastal defense." In little more than a year, March Field would become a major player in America's participation in World War II.

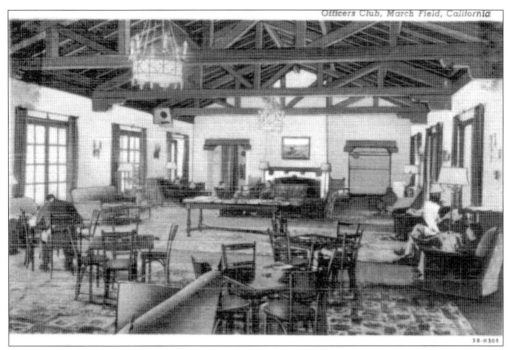

INTERIOR VIEW, MARCH FIELD OFFICER'S CLUB, C. 1943. As one of the Army's major air facilities in the United States, March Field had a few more appointments than many of its counterparts, as shown in this view of the officer's club. Pictures such as this were used to show loved ones "back home" that military life could be comfortable.

VIEW OF BARRACKS AT MARCH FIELD, EARLY 1940s. Many buildings at March Field reflected the Mission style of architecture prevalent in Riverside. Here, with an obvious eye to attract recruits, the caption indicates that the barracks looks like a modern college and campus. (Courtesy of Frasher's Fotos, Pomona.)

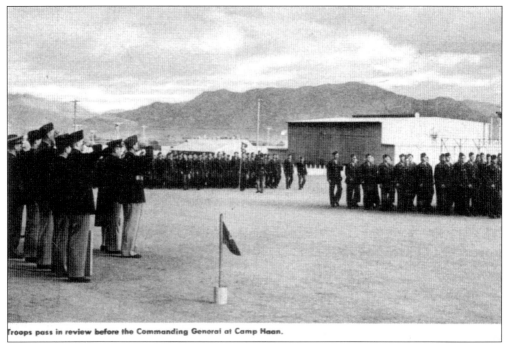

Troops pass in review before the Commanding General at Camp Haan.

REVIEWING OF TROOPS, CAMP HAAN, C. 1943. Camp Haan, named for Maj. Gen. William G. Haan, was located across Highway 395 from March Field and was established in October 1940. It served throughout World War II as a major debarkation point, prisoner of war camp, and anti-aircraft training facility. Camp Haan was decommissioned after the war, with most of the property being incorporated into March Air Force Base.

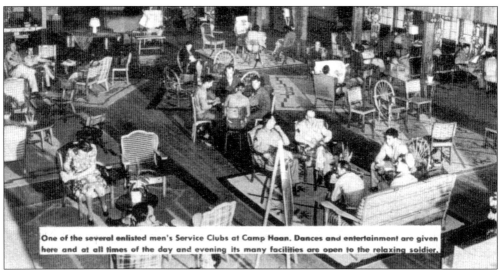

One of the several enlisted men's Service Clubs at Camp Haan. Dances and entertainment are given here and at all times of the day and evening its many facilities are open to the relaxing soldier.

ENLISTED MEN'S SERVICE CLUB, CAMP HAAN, C. 1943. Service clubs such as this one gave recruits a chance to relax and be entertained. The reverse of this card indicates that Camp Haan was "the largest anti-aircraft artillery training center in the nation. When the final battle of this war has been won for the United Nations, a significant part will have been played by thousands of men who first received their training in warfare at this post."

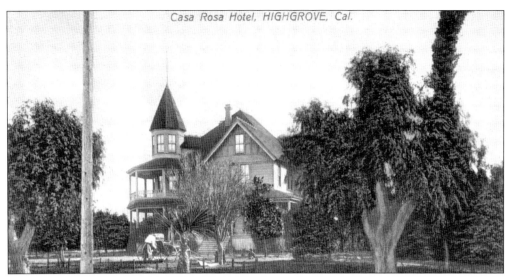

CASA ROSA HOTEL, HIGHGROVE, C. 1910. The Casa Rosa Hotel, located at the southeast corner of Center Street and Highland Avenue, began life in 1887 as the East Riverside Hotel. Highgrove began as East Riverside when the Iowa Syndicate (hence Iowa Avenue) bought and subdivided land just east and a bit north of Riverside. This hotel was the main hostelry in that new town, but later became the Casa Rosa, as shown here. The building lasted until about 1940 when, like so many other buildings of this nature, it succumbed to fire.

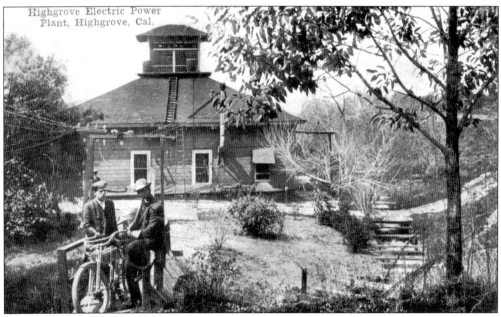

HIGHGROVE ELECTRIC POWER PLANT, HIGHGROVE, C. 1897. This somewhat later postcard shows the power plant that was established on a natural drop in the Riverside Upper Canal near Highgrove in 1888. At that time, the plant supplied power to Riverside and Colton, and was the first hydroelectric power plant to become functional in California. The foundation of this building, along with a Riverside County Historical Landmark plaque, can be seen just off Iowa Avenue.

BIBLIOGRAPHY

Akin, Kevin. *Riverside General Hospital Centennial Book*. Riverside General Hospital, 1993.
Baker, Ron. *Serving Through Partnership: A Centennial History of the Riverside City and County Public Library, 1888–1988*. Riverside City and County Public Library, 1988.
Benton, Arthur. *The Mission Inn*. Published by the author, 1907.
Gunther, Jane Davies. *Riverside County, California Place Names*. Rubidoux Printing Company, 1984.
Hall, Joan. *Riverside's Invisible Past*. Highgrove Press, 1979.
———. *Through the Doors of the Mission Inn*. Highgrove Press, 1996.
———. *Through the Doors of the Mission Inn, Volume II*. Highgrove Press, 2000.
Hall, Joan and Esther Klotz. *Adobes, Bungalows, and Mansions of Riverside, California*. Riverside Museum Press, 1985.
Holmes, Elmer Wallace. *History of Riverside County*. Historic Record Company, 1912.
Hutchings, DeWitt V. *The Story of Mount Rubidoux*. The Mission Inn, 1926.
Keller, Jean A. *Empty Beds: Indian Student Health at Sherman Institute 1902–1922*. Michigan State University Press, 2002.
Klotz, Esther. *Riverside and the Day the Bank Broke*. Rubidoux Press, 1972.
Lech, Steve. *Along the Old Roads: A History of the Portion of Southern California that Became Riverside County, 1772–1893*. Published by the author, 2004.
Moses, H. Vincent and Catherine E. Whitmore-Moses. *Victoria Club Centennial Edition 1903–2003*. The Donning Company Publishers, 2003.
Patterson, Tom. *A Colony for California*. Press-Enterprise, 1971.
———. *Landmarks of Riverside*. Riverside Press-Enterprise Company, 1964.
Pickerell, Albert G. and May Dornin. *The University of California: A Pictorial History*. University of California Press, 1968.
Southern California Edison. *Highgrove: Southern California's Pioneer Hydroelectric Power Plant*. Southern California Edison, n.d.
Stewart, Pat. *Fairmount Park: A Brief History*. Printed by the author, 1993.
Swett, Ira. "The Riverside and Arlington Electric Railway." *Interurbans Magazine*, Vol. 20., No. 3: Autumn, 1962.
Zentmeyer, George A. *The Lighted Cross*. First Congregational Church, 1972.